The Petroleum Manga

A Project by Marina Zurkow

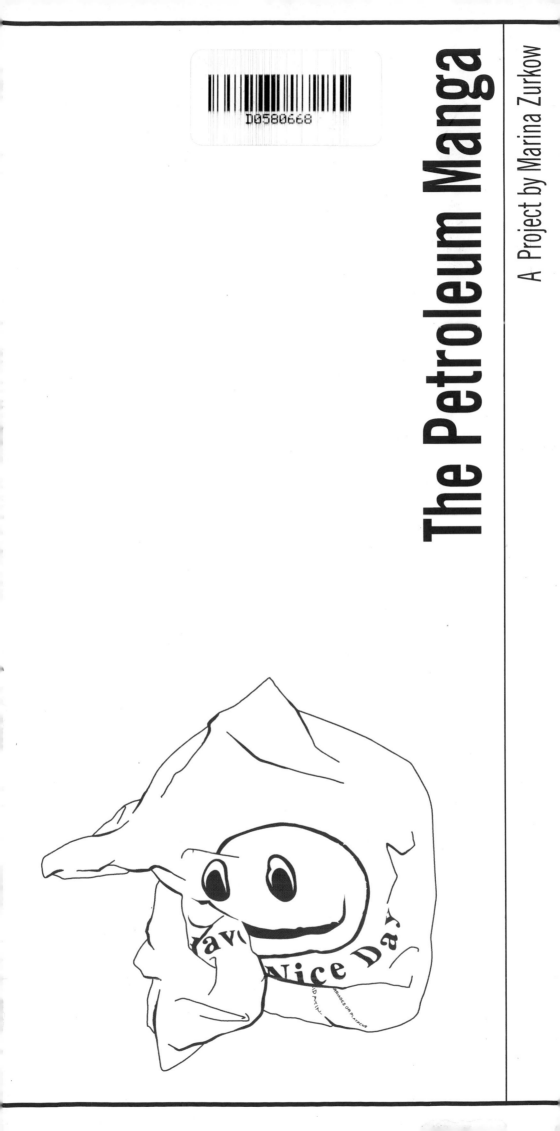

THE PETROLEUM MANGA: A PROJECT BY MARINA ZURKOW

First published in 2014 by
Peanut Books
a literary offshoot of
punctum books
Brooklyn, NY
http://punctumbooks.com

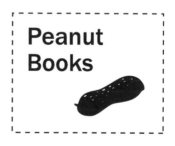

ISBN: 978-0-615-96596-3

Library of Congress Cataloging Data is available from the Library of Congress.

Editors:
Valerie Vogrin
Marina Zurkow

Images:
Marina Zurkow

Polyvinyl chloride (PVC)

Polyvinyl chloride (PVC)

Contents

Contents

Forward

What does a petrochemical want?

This is the animating question we hope to raise here, although by "animating" we don't mean to suggest that a hydrocarbon could possess the qualities of thought and desire we typically think of as being some characteristic qualities of the human....

We hardly notice the plastics and the dyes that dominate our physical world every day. We neither appreciate their beauty nor confront their danger. Their world is a separate space around us inhabited by objects that seemed to just appear one day, whose origins we don't know, whose lore we have suppressed, whose presence we take for granted, and whose immortality we can hardly conceive.

It is that last quality—immortality—that makes so urgent the task of collecting, ordering, and illuminating the petrochemicals and their shaped-plastic offspring, from nurdle to riot shield, football to fetish mask. Their most ancient ancestors were zooplankton, like ours. We could have the same protozoans in common. But instead of evolving, your rubber chicken's ancestors died and fell to the sea bottom, and over millions of years were compressed and heated into crude oil. Petrochemicals and plastics are remnants of life, formed from the deceased by the living. Petroleum, another name for crude oil, is at least 93% (and as much as 99%) carbon, hydrogen, oxygen, and nitrogen. The same four elements make up 96% of the human body. But our plastics will live forever, no longer able to decompose, while we become molecules again. When we are long gone, there will still be plastic clown masks circling in the Pacific Ocean. This, and not our great works of art and literature, will be the persistent legacy of life on earth, these objects crafted out of life's own ancient flesh.

This manga is the record of an attempt to illuminate and categorize a world that is anything but secret and yet largely unknown.

Past Life with Wooly Mammoth

Drought, the true sister of bone, carries bone in her arms, as fossils, as skeletal remains. How can the soul's memory remember this? We walk the land, a dun center. Empty, like a scraped out bowl. Mud puddles and mud slides after the recent, meager snow, churning up animal-shapes in the ravines. What is consciousness? A huge question, fundamental as sandstone or the heavier shale. Ten thousand years ago, the glaciers melted, and now the oil's for sale. Strong winds break in the line of Norwegian poplars. Out of pocket, the stone deposits across the plains. It is a feeling, as in leaves falling, of being left behind, of no longer struggling to hold onto them. To hold onto one's form, is that so important? We went to an ancient sea, you say. The deer browsed the autumn acorns. We were dive-bombed by drunken robins. We went hand in hand through time. The buffalo dozed in the fenced and frozen hayfield.

My Jams

My girlfriend and I ran into Adriana at the coffee shop the other day and the three of us were trying to decide if Cleveland was under- or oversexed. Adriana had just returned from a weekend there where she spent some time with Lori Beth in The Flats. They took their bikes and Adriana's dog, found a wine bar, got fancy cocktails and mini pizzas and were taking pictures of it all with their iPhones before they realized that they were out of money. It was still early, but they were in The Flats and wanted to dance, so they assembled some club-worthy outfits from their collective clothing, hoping they could talk their way out of cover charges and into free drinks.

Eventually they ended up at a place called the Velvet Dog where there was a girl all tricked out in blonde extensions and short shorts. She was dancing by herself to music playing from her phone, and the story wouldn't have been a story but for the fact that her phone case doubled as a set of brass knuckles. For real, I asked Adriana. I wanted them. In the story a guy appears and starts grinding on the blonde woman to her music. Then a cop shows up and tells her that she's not allowed to have a weapon in the club. It's just my phone case, she says. Not allowed, the cop tells her. He tries to get her to give up the case, but she thinks he's trying to take her phone, too. You wanna take my *jams*? She keeps repeating, like she can't believe it.

When I think of weapons I mostly think of metal, steels that need to be cleaned and oiled, heavy things, things that are manufactured, things that transform: heft to velocity to

destruction. Things that are quick and therefore efficient. Drones, grenades, AR-15s. Tanks, missiles, rifles. But I can also think in the opposite direction. First fists, then obsidian arrowheads, maces of bronze, clubs, quarterstaffs, pikes, and sabres. Such weapons were handcrafted in their day, and I imagine that individual artisanal innovation was highly valued—it was, after all, what turned iron sharp.

A few years ago I took self-defense classes. I think a lot about what the women teaching us said. Anything can be a weapon; your own weapons can be used against you; preserve yourself while destroying what you hit. Use heavy things, things that are manufactured, things that can be thrown: a rock, a pen, a small radio. But what of the woman who dreams of a return to individual artisanal innovation, who wants Etsy weapons, a do-it-yourself defense? For her, there are 3D printers. Instead of obsidian, bronze, wood and iron, there are spools of ABS (acrylonitrile butadiene styrene) filament. Instead of chiseling, carving, and hammering, a nozzle heats the plastic and spits it out in layer after microscopic layer. Those layers fuse together into whatever their creator wants them to be. A phone case, brass knuckles, a combination of the two: a weapon both medieval and ultra-modern, an infinitely customizable weapon of brute force. When you create and use these plastic knuckles, fists will fly, bones will be fractured, and bruises will spill out across the skin. There will be the body before the fight, and the body after.

Half

For half of the year, when her father was working, it was as if she weren't half made of him. But during the summer, he worked on the car in the garage, and she'd play near his feet with bolts, stubby screwdrivers, the ratchet and its sockets, and the wrench that looked like a dinosaur. He cursed a lot, headless and heartless, but not at her. She knew all the tools, and when he called, she handed each into the dark, grit from the garage floor pressing into her legs. The holes in her father's jeans, her father's sandals, the hair on his toes, the all-around blankness of his feet, his voice, bouncing and metallic, distant and safe, the general quiet mess, all there beyond her eyes.

When she comes home from school on the day of the apocalypse she's fifteen. The garage door has closed on her father. Waist down he is in the driveway. The rest of him is in the garage. The garage is suddenly a mouth that has shut already. She thinks of the mysterious fall of the dinosaurs. She thinks of the movie of *Captain's Courageous*, which they watched together, she and her father, on late night TV, and she remembers the pleasure of being included in his insomnia, this new other half of sleep, looking at the side of his face in the television light, like watching someone sleep, like being a ghost. Spencer Tracy bobbed among sharks, truncated in the water. They'd been reading "Ozymandias" in school, and she was still thinking about the word *trunk*. They'd been talking about Persephone, the pomegranate, and the two ways people tended to pronounce her name. In grammar, they were going back to tenses because nobody seemed to get it after all. "You're slipping!" said the teacher. Her father lay far away in a new way: something about viewpoint, something about organizing principles, something about presence, absence, something.

11

Petroleum Troubador Machine

older than English
petroleum
breaks a rock
into Latin oil

so ingenious
the humans
who crack rock
for sticky ichor
that runs in the veins
of the gods in the rock

how the ground seeps
what millennia keep

would the new little god
suck the thick wick
lick the slick rock
whisk away the oil
slickening yr crude thighs
yr hydrocarboned eyes
so barely evolved
compared to ancient
pressurized unguent sighs

dig my hole
and frack the soul
douce dame *pétrole*
so long coal
hello petrol
my black *soleil*
released this way
blacks out the sol
o look *el sol*
el sol

Chicken Shit

The chicks give him visions, their cheeps outside his window a hopeful, intermittent song that shows Tyler something different from empty lots of Herriman bricks and trash tumbleweeds. He'll repaint the empty downtown gold with dabs of feather.

When he was a kid, Tyler got tickled by the sight of the chickens on the road back from visiting his grandparents in the country. The way they pecked the dirt, hunting grubs, contemplating what was on the other side. His parents meant well, so they bought him a pair of hens, raised the sides of an old doghouse to make it a coop. Taylor loved those chickens, named them Gregory Pack and Chicken Korea, and loved their eggs even more, perfected once he scraped the shit off them with his thumbnail. He buried the eggs, thinking, somehow, to protect them till the chicks were ready to tumble up from the earth, golden lava. That dirt

mound exhaled sulfur, what to expect from a volcano, but never baby chickens. After two weeks of anxious waiting, he dug up the eggs and made them missiles, mashed against the side of that dog house. The two hen's feathers grew dusty, and Tyler wandered away to stare into the sun. When the hens' necks were rung, their dirty feathers plucked, Tyler ate those gender-confounded fowl.

For many years after that, Tyler didn't think much about chickens. He painted yellow suns and rainbows, combat boots and nudes, cubist boom boxes and blocks of ugly color. He posted pictures to the internet, seeding the web, and then backtracked to read the comments people had made on his art, adding his own comments, starting the process again. It was farming, of a sort, he came to understand; he needed to keep farmer's hours to follow up on what he'd planted. He started to build life-size erector sets, called them "environments." They were air-filled frames to live in. At the housing store to buy more girders, Tyler saw the display: cross-stacked bags of Super Turf Builder® with Plus 2® Weed Control, piled so high he couldn't see the top. He stopped, stared, had a vision of a cock crowing atop a giant dung heap. Tyler bought more bags than he could afford, enough to bring his vision closer to earth. With that much fertilizer, one could renew anything, grow anything.

Cracks in concrete, curbs? Seeded and slathered with chemical mud, and check, they grew. Flat black boxes, lined with fertilizer and seeded, brought up bright flowers. Chains of petrochemicals brought it back, bonded life to life. Buried biomass, breathing again. That's where it started, his dream to revive a city block, buildings torn down and gone to seed. Chicks were first, from the farmer's market, carried in an egg carton, someone's idea of a joke and you could close the lid to make the chicks sleep. Let them have the run of the rows of parsnips he planted. They ate grubs, green shoots, whatever. There was a whole cycle of life happening here, Tyler saw, and he made plans.

Chicks could eat chicory, blooming blue flowers beside parking lot stops. He got some seeds for rye grass and spelt, and he thought, goats, bring them in to trim it back, bleats sounding enough like people to make the block sound busy. Cows for milk and horses, why not, for pony rides, and bindweed and fescue to feed them. Bushes and shrubs and llamas. Why not camels, now that he was making a menagerie? Plant trees, Dogwoods, even. Add a dinosaur. He wasn't sure yet what kind, but they all came from eggs, he thought. Fertilized, anything was possible.

He'll start it all again.

Meth

On the road to ruin a man in the maroon car was on meth and driving like it. The girls lagged behind for safety. Couple days later they saw him at the store with a boy and a puppy. A.J. got nervous. She didn't know where to put her eyes. The puppy was so cute. The boy was eating out of a plastic bag and the man was carrying the puppy. They crossed paths on the porch of the store. Behind them was the beautiful landscape. The man wasn't carrying any groceries but then they were all on their way back toward the maroon car. The man carried, carried, and carried the puppy. He was a little handsome. Maybe the man didn't have teeth. The boy was cuter with every bite. Give me a break, this is not the end of the world.

Kim had said, as they were parking next to the maroon car, "That's that car from before that almost killed us." It had gone up and down the curves in the mountain road as if there weren't curves, just straight ahead on methamphetamines. They saw his teeth for a second and they still seemed pretty okay. One thing A.J. always knew was if she lost her job, without dental she'd finally start flossing like clockwork. They went up the stairs onto the porch of the store. Kim said to the boy, "Is that good?" and the boy nodded with a lot of energy. Kim patted the puppy's head in the man's arms. Then, in the store, she started looking at the shelves. That was about it. Puppies and little children.

Live and let live? Down at the breakfast shack a man is eating a breakfast burrito and he's the father of a kid he beat, who another lady in the town adopted, and they all live *here*. A.J. felt angry. "I am not adopting that boy and that puppy!" she thought as she passed by them with her purchases, bags swiping the door of his car.

The Plastisphere

If you've heard of the "Great Pacific Garbage Patch," or ocean plastics in general, you may have wondered why we don't just clean it up. You may have even seen inventions with long, floating arms and fine bristles like The Ocean Cleanup Array designed to do just that. Yet, you may have also heard counterargument from scientists and activists saying that clean-up is a fallacy that fundamentally misunderstands the materiality of ocean plastics.

The vast majority of ocean plastics are less than five millimeters in size, called microplastics, and they are inextricable from the larger oceanic ecosystem. Plastics are dispersed unevenly both in terms of where they are in the water column, and where they are in each of the world's five oceans, though they are in every ocean. In very few cases are they bunched up and scoop-able, even within concentration points in gyres. Instead, most microplastics are strewn within, and even constitute, ocean ecosystems. Animals as large as whales and as small as plankton ingest plastics as a matter of course. Miniscule plastic particles circulate in the blood of mussels. Microbes and marine life live on floating plastics. Reef fish, until recently confined to shorelines, have been found in the deep ocean thriving next to plastic flotillas. Scientists dub these unique ecosystems "The Plastisphere." (The Plastisphere is one of the many industrial-natural ecosystems that characterize the Anthropocene.) Cleaning ocean plastics, even if it were technologically possible on a scale that would make a difference, would disrupt and destroy the life we would be trying to save in the first place. Plastics are not inanimate objects separate from life; they are now full, permanent participants in all living systems.

The Plastisphere extends beyond oceans. All humans tested everywhere in the world, including Indigenous peoples in the far north and plastic-free American Mennonites, carry chemicals in their bodies that originate in plastics. Flame retardants, phthalate esters, and other chemicals migrate from plastic products and accumulate in human and animal tissue. The most recent Center for Disease Control count has more than 98% of Americans carrying a body burden of over 100 industrial chemicals. Water-soluble plastic chemicals like bisphenol A (BPA) circulate through the body in about six hours, yet even people who live largely plastic-free lives have constant levels of the chemical in their bodies. Most of these promiscuous chemicals are endocrine distributors, meaning they do not invade the body like a poison and break down cellular processes, but instead act just like a hormone, fully participating in endocrine systems that regulate puberty, fetal development, fertility, obesity, heart health, and countless other systems. It is difficult, and often impossible to scientifically differentiate between the body's natural hormone activity and the effects of plastic chemicals.

Plastics in the twenty-first century are ubiquitous, especially given their longevity, but they are also intimate.

Three Scales of Plastic

The three scales of plastic are functional, molecular, and geological. Swallowed pharma need all three to work, but the scales are not the same. At the functional scale, pills fit into human hands and mouths. Our eyes respond to the bright plastic of the capsules and the designed pink

of the tablets. The pills can't be too large, small, or bitter. The capsules can't dissolve in our fingers. Inscriptions must be legible if the package gets lost. And the songs and images that stir desire for pills and capsules: marketing works at the scale of function too. Even the molecular action of the ingredients loops back to this scale. If the pills don't work, the little acids haven't cycled back to perception. Maybe their failure will steer industrial flows of aspirin.

The molecular scale is different. *Inter alia*, the pills and capsules contain the petrochemical phenol (C_6H_6OH). Phenol is a phenyl group bonded to a hydroxyl group. On Earth there is a new stratum of phenol. It's a stage of molecular history. But it's not a historical stratum in the way of the exhaust carbon laid down in ice fields. Everything that contains phenol participates in the stratum of phenol. When we swallow pills and capsules, the stratum of phenol clicks into the smallest capillary pathways of blood, like the submarine in *A Fantastic Voyage*. The stratum of phenol traverses our pills, capsules, and bodies, but also clicks into place in nylon, epoxy, dyestuff, and explosives. Through chemical weaving in pipes and tanks, the *cumene* process makes phenol from oil.

Oil is the *longue durée* of pills and capsules—from Permian strata under West Texas, to forms you can hold in the palm of your hand. At the distal end of the process, swallowing an aspirin, the long arm of geological time-matter reaches into your stomach. In this way, undead seas of oil have a role in the most unexpected actions. Oil was tree ferns, bryophytes, and strange fish; its molecules were a million now-extinct forms. Even though they're dead, they're not not life—not fossils, not yet minerals. Meanwhile, the word "aspirin" is written in a little medium of oil. Words always take a bit of meaning from their media, which means that oil, through phenol, shades the sense of the word we read. Something of the strange fish now alters the meaning of "aspirin," as nameless ferns go to work in capillary passages.

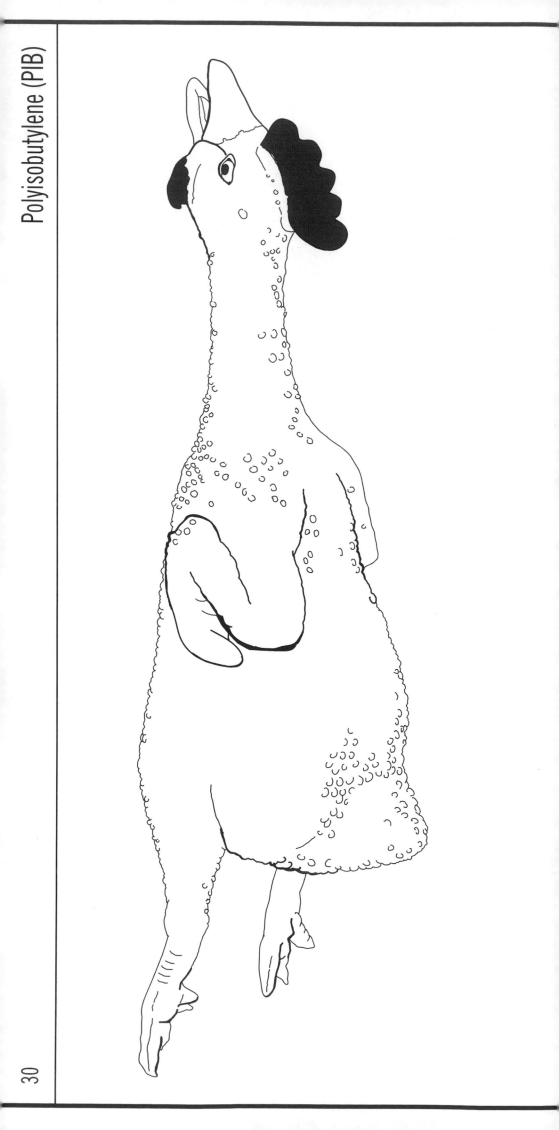

Rubber Chicken

Rubber chicken: it's a joke, a plastic toy, all yellow skin and brown bristles, brandished by The Three Stooges. Or it's something served on the campaign trail, the "rubber chicken circuit." Or its Diogenes' rejoinder to Socrates—a featherless biped standing in for our humanity, all flaccid flexibility. Whatever it is, it *isn't* the heritage chicken Portlandia hipsters savor as the foodie replacement for the plastic-and-yellow Styrofoam packed Perdue oven-stuffer roaster, nor is it the free range chickens I raise. The rubber chicken—plucked and pimpled, flat and staring and dead—surely has nothing to do with the dusty feathers, bright red combs, and warm scaly feet of the hens that let me pick them up when I first go out to my henhouse in the morning. And yet....

Wearing my Wellies, I scooped my first hens up my sister's farm and brought her home in the trunk of my car, driving forty minutes across the Pennsylvania ridges and valleys carrying that hen in our Prius, getting roughly 45 miles to the gallon. Our next chickens came from the Belleville Farmer's Market in Big Valley. We traveled forty minutes in our car to get to the market (another two gallons), although others in the crowd had walked there, or come on bicycle, or traveled in the carriages (dark golden, light yellow, or black) of the Amish. The auctioneer used a battery-powered mic to sell the chickens to his audience of fifty or so, hunched around him in their webbed aluminum chairs. In the building behind him, stacked cages held not only rabbits, guinea pigs, and identical yellow straight run Cornish Rock-Cross chicks, but also giant red and blue Macaws, a Golden Cockatoo, and a Columbian Yellow-head Parrot, who climbed upside down across the roof of his cage with gnarly nobbed feet, screeching at the top of his lungs. The chickens probably came from U.S. breeders, but the exotic birds, trucked up from Philadelphia, had been shipped there from South America and Asia, sometimes legally, sometimes not, but frequently biologically risky for sellers and buyers alike. And always petroleum-intense in their lengthy transit.

I stopped going to Big Valley for my birds when some chickens from Belleville brought home mites, lice, and respiratory diseases. Instead, I placed web orders from Murray MacMurry, the Iowa poultry hatchery: day-old chicks, hatched in incubators powered by gasoline, kerosene, or electricity (probably generated from coal or oil rather than wind- or solar-powered), and flown in on a Fed-Ex jet. (Poultry farmers have been sending one-day old chicks by mail since the early twentieth century, though many people worried that chicks sent that way would suffer from the rigors of travel. And these mail order chicks have always required petroleum, whether for the Model A and T trucks that first carried them, or now for our regional jets.) I drove the chicks back up the hill, installed them in the plastic kiddie wading pool under the electrical heat-lamp (at least half powered by our solar arrays, but of course those were installed by gasoline-fueled machinery) and waited for them to grow. These birds would be free range. But as this avian inventory—this *thought experiment*—makes very clear, they too were rubber chickens.

Floats

Sherry and her best friend Melissa head up to the roof with everything they need to hold them from 10-2, prime tanning hours: folding chaises, beach towels, foil reflectors, baby oil, yellow Toot-a-loop, eye protector (Sherry's mom insisted), pack of Eve cigarettes (in glittery vinyl case), cooler full of Tab, a can of Pringles, a couple of old *Cosmos*, a copy of *Flowers in the Attic*. It's early April but it's sunny, and the girls want good tans for the spring dance. Sherry already has a boyfriend but Melissa doesn't.

Sherry's gotten as much flavor as she's going to out of the three pieces of Bazooka in her mouth; spits it over the side of the roof onto their Brooklyn sidewalk below.

Gross, Melissa says.

What? No one's down there. I looked.

Someone could step on it.

Someone will step on it. That's how it works.

Melissa could ask 'that's how *what* works?' but just shakes her head. The girls lay their towels out on their chairs, take their T-shirts off, leave their jean shorts on, oil up. Sherry takes her training bra off as well, looks at Melissa, who's still wearing hers.

You're going to get lines.

Someone could see!

No one comes up here.

They could see across the way. Melissa points to a taller building a block away.

Suit yourself. I'm wearing a halter dress to the dance. I don't want lines.

Sherry opens her reflector, positions it at the waistline of her jean shorts, puts the eye protectors on, leans back.

Melissa unhooks her bra, lays back. All she can think about is her nakedness. Here I am on the roof of our building,

naked. Melissa doesn't tend to look at herself naked, doesn't tend to be naked much, outside of the shower. Melissa is slender, with the typically taut skin of a fourteen-year-old, won't realize for forty years how good she looks, then or ever. All she knows right now is that she feels about as self-conscious as if she were actually doing anything up here on the roof, having sex or something. In about all of three minutes on her back she turns over onto her stomach.

Donnie could bring someone for you, if you want, Sherry says.

Bring someone for me?

A date. His friend Eric is alright-looking.

Oh.

You'd have to like, try not being a prude.

I'm not a prude.

You flipped over in like, a minute.

That doesn't mean I'm a prude.

Have you ever Frenched anyone? Sherry knows the answer already.

I'm not going to just French anyone. I want to like them.

You have to just get it over with.

Gee, you make it sound so appealing.

Gee? Are you from *Father Knows Best?*

Melissa doesn't want to have to explain sarcasm.

Do you want to practice?

What, Frenching? With you? Ew!

You should be so lucky.

Melissa is not a lezzie, does not want anyone anywhere to ever think she might be a lezzie.

You're going to have to learn sometime.

Melissa says nothing. Today is not a day for learning. She flips through a *Cosmo*, comes across tips for turning on your man, puts it back down. She turns on her Toot-a-loop, fiddles with the dial and lands on "Rocket Man" by Elton John, floats into it. Melissa loves Elton John, loves this song, this song speaks to her true self, even if she doesn't fully understand the lyrics, maybe even not at all. But she feels better already. Melissa rubs some more baby oil on herself. Today is about the perfect tan.

Body

After graduation, their daughter's madness burst from her head full-grown. By the time she was pronounced dead of medications, she was bloated with fluids and bubble-wrapped in the watery light of the ICU, with tubes and the green hum of numbers reflecting on the walls. Blisters like jellyfish rose on her knuckles from being pressed to the carpet under her body weight. No one is blaming the people lined up for organs. The mother and the father stood over her in every way you can think of. The father put ointment on her eyes and closed the lids. Next is a line about the father that I can't write. Next is a line about the mother. Next is a line about there and not there. Then on the morning of the fourth day, their daughter woke up. She made noise through her tube. She said, "I drowned?" She pointed out some hallucinations. When she saw her fingers down the blanket, she guessed carrots. The carrots were down at the edge of her body, over near her parents as part of the skyline, pointing at any number of endings.

Pacifier

The butyl rubber, that is, synthetic rubber of a baby's pacifier has "excellent impermeability," according to my Internet sources. Two companies are largely responsible for the substance's manufacture, one being ExxonMobil.

The pacifier, though it offers no physical nourishment, replaces the nipple in a baby's mouth, subs for the mother's breast when the breast itself is absent. My mother was a nursing mother—a La Leche League leader in the 1970s—and as a mother I would duly breastfeed my children also, more than three decades later. But despite the ready availability of the breast, at age two I was not satisfied by part-time nursing. So for almost three years of my life I went around constantly with one of these petrochemical lollipops in my mouth; I could rarely be sighted without the fake-rubber protrusion on my face. I was deeply fixated on the item, which I fondly called a "zaza." I still remember the last one I owned, which I finally lost and which was not replaced by my mother despite terrible wailing. I had to relinquish the thing to graduate from toddlerhood, possibly; I was too old for it, I no longer qualified for the breast substitute.

As an adult, once—home at my parents' house for Christmas, I believe—I came across an unused zaza in a drawer and out of curiosity (and admittedly no little compulsion) stuck it under the tap and then popped it into my mouth again. The smoothness, the fulsome perfection of that pliable oil-based nub, filling the mouth—I found it satisfying, I'm not prepared to lie. For a few fleeting moments, it was as though I wanted for nothing. I saw the prospect of a whole society of adult pacifier-suckers, how fulfilled, how gratified such a society might feel. I saw us all going about our business, briefcases in hand, zazas in mouth: our level of contentment was high.

But walking around the house with the nub in my adult mouth I was instantaneously shot down. I presented an obscene, perverse figure. My brother, my sister, and my parents begged me to take it out of my mouth right away; not even five minutes would be permitted to me. All four of them were visibly distressed. What had been cute in a two-year-old was clearly repulsive in a woman of twenty-eight.

I removed the pacifier only with great reluctance.

The Heap

I pause at the gate and prepare myself—morally, I mean—to stamp and ululate, to scare the mites as may be necessary. These are small brown things who smell of refuse and cover their faces with bootblack. They pull tiny barrows attached to rope threaded through the waistband of their childshorts, and wear transparent gloves. The heap has made them agile. They operate as tribes, the strongest, of course, operating in this, the largest heap. The head of each tribe does not pull a barrow, but instead carries a truncheon; it is not clear if this is for strangers or the less productive.

Tribes are identified by the colored napkin they wear over their nose and mouth. This heap is tended by a yellow tribe, whose leader paints her teeth black and howls.

The mites call to each other in a coded language of numbers.

Even from the gate I smell foodstuffs made rancid by the summer sun, the green rot of plumage and dampened tree fronds; I hear the rustle of rodents, and the roaming of the yellow tribe, the squeaking of their barrows.

I cannot see them as I skirt the edges, endeavoring to find a spot where the odor is less repugnant. I shall not tell you what I unearth with my broom end; not even a starving man could contrive to hide such on his person, much less consume it with his mouth.

Consoling the dying has made me less squeamish about infection and age in a meal, but even I am sickened by putrefaction. I have stored little in my breeches when I am felled from behind by a truncheon at the knee, my face landing in a pile of rotting greens. I had not heard the mite approach, perhaps because it carries no barrow. It is the leader, who has taken exception to my trespass. She turns from me to call her tribe, and I twist and fell her, also at the knee, with my broom. She lifts the napkin from her mouth and howls unintelligible instruction. The mites swarm. My knee feels broken, though I know it is not because I am able to stand and run, though it seems the fire in my leg will consume me.

I do not run far, for I place myself always near a gate, and the mites do not leave their heap for fear of other tribes.

From the safety of the road, I consider my repast: a handful of burned groats and a black banana leaf. I eat them quickly, ensuring that no grain lands on the pavement without being recaptured and immediately consumed. Such is my dinner.

After dining, I remove my tunic and breeches by the river and cleanse them, with special care for their edges, which dipped into compost. This is my nightly ritual, to clean my clothes, though it shortens their life, and leaves me cold and naked through the night; as a result of this ritual, and this ritual alone, perhaps, I consider myself man, still.

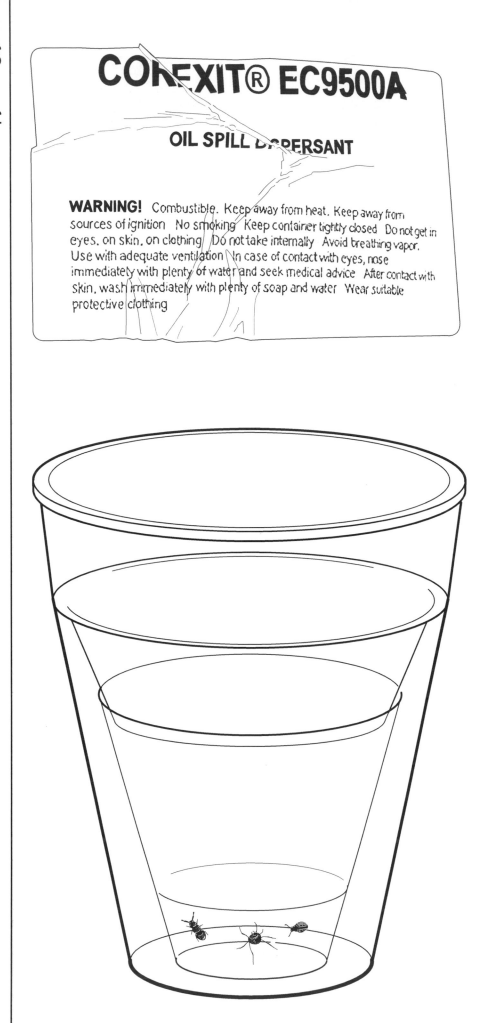

COREXIT® EC9500A

OIL SPILL DISPERSANT

WARNING! Combustible. Keep away from heat. Keep away from sources of ignition No smoking Keep container tightly closed Do not get in eyes, on skin, on clothing Do not take internally Avoid breathing vapor. Use with adequate ventilation In case of contact with eyes, nose immediately with plenty of water and seek medical advice After contact with skin, wash immediately with plenty of soap and water Wear suitable protective clothing

Freeze Box (Mama's Got A)

Now, in the near future, we'd already perfected the cryogenic freeze-box for some time. We used it for everything, for animal and vegetable, but best was we could crawl in there for grieving. Let the psychotic teen shoot our mother, let the caped man rape us. We crawled into our machine to work through it all in distant dreams. Over time the teen used her own cryogenic box to wait through the delusions, and over time the caped man slept his rage away. Those of us awake on earth walked peacefully, and when we couldn't walk we slept until we awoke to the clean air of past sadness. Freeze-boxes lined the hills and followed us like wagons, but still came the end of the world. We saw it coming, and towards us it crept, over time, a horizon. We kept our cryogenic chambers near. We were getting so sad, watching it approach like soldiers. We gazed across our freeze-boxes, into the eyes of one another, waiting for the right moment. We didn't want to leave, because finally it was all so beautiful.

Ghost World

We know only too well how plastic actually lives among us: in shiny bright colors and compacted, solid, ever-proliferating forms. In contrast, these ghosts of plastic are monochromatic, flat, and spare. They float before us, fine black lines on stark white surfaces. Many of them congregate in surprising combinations, obeying a rigid taxonomy of chemical origins. One group comprises: a set of brass knuckles, a Slinky™, an Afro comb, and an exit sign. Another consists of a bouncy castle, a bondage mask, and a cut of shrink-wrapped meat. The logic of their assembly is revealed by the unobtrusive tag on the top right hand corner of each poster, the name of one of several petrochemicals: polystyrene, polyurethane, ammonia, nylon, etc., along with the abbreviations made necessary by their ubiquity: PET, PVC, HDPE, PMMA, ABS.

But these ghosts are not content merely to represent a kind of petrochemical: they seem bent on assuming certain secret, esoteric formations—on lining themselves up, or aligning themselves with, other ghosts, both within their group and in relation to the figures in other groups. Goggles congregate with helicopters, umbrellas with hairbrushes, IV bags with flip-flops. The ghosts of plastic perform an enigmatic choreography. It's hard to tell if it's surreptitious or exuberant, if it's going to multiply their powers, or reduce them, or alter them.

What makes the ghosts of plastic dance together? Is this a ritual exorcism they're engaged in, to stem the tide of Stuff that has been their story in the world? Artificial, synthetic, fake, faux, valueless, junk, crap: that tawdry story's nearing its end anyway. Maybe this is a mournful, moving, memorial the ghosts have gathered for, building a monument to their

own disappearance. Or rather, to the passing of the plastic world so many of us have lived in for the last hundred years.

These ghosts are the hieroglyphs of that waning world. They record, for millennial futures, how we lived and loved plastic, how we fed on petroleum, how we built our lives on benzene. Like the hieroglyphs that commemorate ancient pharaohnic histories, the ghosts of plastic will tell of our daily lives (Afro combs, exit signs) as well as of our systems and secrets (brass knuckles, bondage masks). They will memorialize our absurdities (rubber chickens) and our advances (rolling suitcases), our necessities (Pampers) and our superfluities (Pampers), our hopes (silicone butts) and our fears (parachutes).

The Ghost World of the Petroleum Manga is here, now. We are already living with the knowledge that one of the worlds we made—the one we made most recently, out of the false promise of endless, inexhaustible, malleable matter—is exhausted. (The "Resource Curse" is upon us; it does the same thing to us as it did to countless poor countries: it destroys.)

But perhaps the ghosts of plastic are not only memorials but also harbingers. Maybe they are dancing us into another world, the future that will follow the end of petro-modernity. As psychopomps, the figures of the Petroleum Manga, with their clean lines and austere palette, may be promising us a calmer, simpler world ahead, freed from the production-compulsion that made plastic our king and soaked our lives with chemicals. In that new world perhaps we will be able to pursue our pleasures and confront our demons in the safe spaces of imagery and imagination, without having to unleash them into tacky, synthetic existence. In that world, we will be able to see, and celebrate, the strange beauty of the Petroleum Manga.

Watering Can, High Density-Polyethylene

For decades, chicory and plantain curl still
from the stocky temple,
seedheads drifting past the spout.
And when the floods rush in,
it floats, a vessel,
one might say,
for a civilization's belief, its poise—
its hope?
Some say the temple's gods toss on in the belly.
Some say they died for the temple,
and did not rise after.

Industry

I worked in a plastics factory when I was nineteen. We manufactured the five-gallon jugs that industrial size cooking oil comes in. I was not proud of my work. No one was. We weren't proud of the paycheck either: two dollars and fifty cents an hour. It was assembly line work. We stood for two hours in one spot, ripping forms from the plastic background they were cast from, slicing the faulty ones with utility knives and sending them back into the forge, burning our fingers. The air was blurry with white plastic particles, like the plankton and plankton-like plastic that clouds the waters of the oceans now.

We waited for our two fifteen-minute breaks and our lunch (a sandwich and a cigarette). No windows anywhere. American Plastics, it was called. American Plastics, American Rubber, American Home Foods. National Rubber. All those factories closed down now. Shame of

plastic and the married salesmen. Burnt smell of it, perfume spread on toast. Men passing out in the foundry. Women with curlers, at work on the assembly line. No one suggested masks or ear plugs. What the American workplace did to everyone in the 1960s. Good place to get a job, better than fawning, for a girl, better than secretarying.

Shame at not understanding until later. In balloons: what the sea says. What the landfill says. Shame at our bigness, ugliness, now age. Shame at our shameless grab for attention. That we must stand taller. That we can forget names. That we are increasingly left to our own devices. Over-rounding the corners, over-praised. Where is the life within this one once we've erased it? When we think of ourselves in the future tense, already gone? God-particles, thus. Almost eternal.

Wipe That Face Off Your Smile

My mind snags on the ghostly face, like a plastic bag shredding in a tree; shape-shifting, lingering. I've filled it to plumpness at the grocery and crumpled it into a cupboard, a forgotten mass. And yet the bag does not forget me. Its Cheshire smile clings with an impossible ephemeral persistence, the sign that swallowed its signified.

I've seen that smile before, in a 1946 Standard Oil industrial film. It belongs to a talking carbon atom, an inky blob, who demonstrates on his own round black body hydrocarbon bonding and carbon splitting, both modes of proliferation crucial to keeping commercial gas cheap and plentiful. Heated to a rhythmic *boing boing boing,* the Standard Oil spokes-atom erupts magically in two, in what can only be described as a work dance, extolling his own exploitation. With his four-fingered white glove extended toward anxiously waiting hydrogen molecules, the carbon is Sambo, the golliwog, a tar baby reengineered, reanimated from the Land of Cotton to serve the petroleum economy.

Slavery lives on, beyond legal redress. Its ontological scandal—the exchange of human for thing—permeates and undermines assumptions of a proper, whole human body. Slavery's carbon footprint reveals itself in the servile plastic grocery bag, through its overproduction and our unthinking use of it. It lives on in the taunting smile, and in the desire

of the parts to live and seek other parts, and for those parts to have parts of their own.

These hyperactive hydrocarbons, the forgotten, excess and abject parts—a plastic bestiary of rubber chickens, alien kewpie dolls, goggle eyeballs—have burst their cartoon ranks, and like a Looney Tunes Sambo, threaten to cook pith-helmeted Elmer Fudd in a big black pot of boiling oil. The slave revolt that never happened haunts America's hollow prosperity. It lives on in an environmental consciousness that barely contains a revolution of the ecological order: the fear that things will take over.

That insinuating smile suggests it was petrocarbons all along that set the stage for the anthropocene, the narcissistic misnomer for how man's free-flowing anxiety has finally achieved objective correlative in the undoing of the human.

Vast Field of Discernible Objects

I miss my '86 Land Cruiser, I miss
what it did to my life. My dog could ride in there
and it was like everything bad blew out the window,
hair, dust, despair, etc.
I miss my Land Cruiser the same way I miss
my rubber mask which I wore because
it was called "mop" gear and there was gas
and we played football inside of the gas
in these heavy clothes and masks
until we collapsed because we couldn't breathe.
My umbrella has a name, it's Henry.
My hairbrush has a name, it's Joyce.
My glock pistol has no name other than glock
pistol. A razor and utensils would be a good
thing not necessarily. Why am I me? says the mask,
couldn't I be someone else? No, you
can only be yourself in the manner of an electrical cord
bundled up yet still inside of the socket.
I love her and miss her, or is it the mask
that is talking. No it is not the mask, it
is about how objects shape us,
extinguish us even, make the heart
inside of the echo grow teeth.

In spring, each year, a blizzard hits
just one house exactly, tons of snow
dumped upon it like an insane drapery
stuck inside a little kid's fist. And everywhere else,
it's sunny, like an ice skating rink
thrown upside down to melt.

STRIA

Intimations of Immortality in a Petrochemical Harp

> *The dead rule and confuse our steps*
> Frank Bidart, "In the Western Night"

> *I made a harp of disaster*
> Louise Glück, "Lute Song"

Necrocracy, the rule of the dead. How do the dead rule? We make worlds composed of lifeless things but trick ourselves into believing we will never join them in the dark and, as Hamlet put it, "undiscovered country, from whose bourn / No traveller returns." The fantasy of eternal life? The harp is the emblem of eternity, and the development of its disaster spans centuries.

Time immemorial. Art as triumph over mortality: nowhere more clear than in that founding figure of Western art, Orpheus. Already with his song, he could charm beasts and make inanimate nature move with nothing more than voice and lyre. When his beloved met her untimely fate, Orpheus descended charmed tears from the dry eyes of the rulers of the dead. They released Eurydice on the condition Orpheus not look upon her until they returned to the surface. Orpheus looked, and Eurydice was lost once more. As the singer mourned, his song drove made the world grieve too. What is a harp? It is the engine of eternal redemption, the engine of sorrow's dissemination, the engine that enchants then disenchants.

The Romantics. The miracle of the Aeolian harp, named not after Orpheus but the wind god Aeolus. The instrument, invented by Athanasius Kirscher around 1650, was designed to be played by a breeze. And so the idea that some force called Nature makes Art through a play of forces manifesting greater and higher truths. The instrument came to be a signature of the poet's mind responding, with song, to those forces. Samuel Taylor Coleridge's "The Eolian Harp" asks:

> And what if all of animated nature
> Be but organic Harps diversely framed,
> That tremble into thought, as o'er them sweeps
> Plastic and vast, one intellectual breeze,
> At once the Soul of each, and God of all?

Little did Coleridge realize, distracted by the battle between the organic and the mechanical, that *plastic* would come to be not just the quality of being susceptible to shaping but more potently the signature substance of a whole new age.

Now. What's a harp made of? Fantasies of immortality. Also, petroleum. The casings of most harps still tend to be made of various kinds of wood and some strings are still made of gut or catgut, short for cattle gut and referring to fibers drawn from animal intestines. Wood and animal string secure art's connection to the natural world. Yet players now pluck

nylon as they coax their harps into song. Once we believed that art played at the frequency of nature and could suspend time. Now time is coated in polymers, and the winds brush over a harp of plastic strings.

Georgian Heat

When scorpions scuttled across her bed,
a cold can of Fanta pressed
against her brow, the same week skeletons
of locusts—gold as Fritos, big as hockey pucks—
had been shoveled off the streets, dumped
into the Tblisi sewage system, Mrs. Beniasvili
looked past the jeremiads of scientists
their data and admonitions, reached back
beyond the seventy years
under the hammer and sickle,
the two thousand years under the cross
to that place we all believe in at midnight.
She reads the fingerprints of deserved disaster:
either God is angry or Satan is winning.
For the folk of Tblisi, the snakes sealed it:
the Devil himself slithering through the mind-melting
heat, a kiln for concoctions in this country
that lives on fear and extreme emotions.
When you are worked up, you are alive.
Maybe the Georgians are on to something,
I think as I stand in Best Buy, facing
the steep cliff of the air conditioner wall,
cheery blue ribbons snapping out from the wind
of the grates, flicking me in the face.

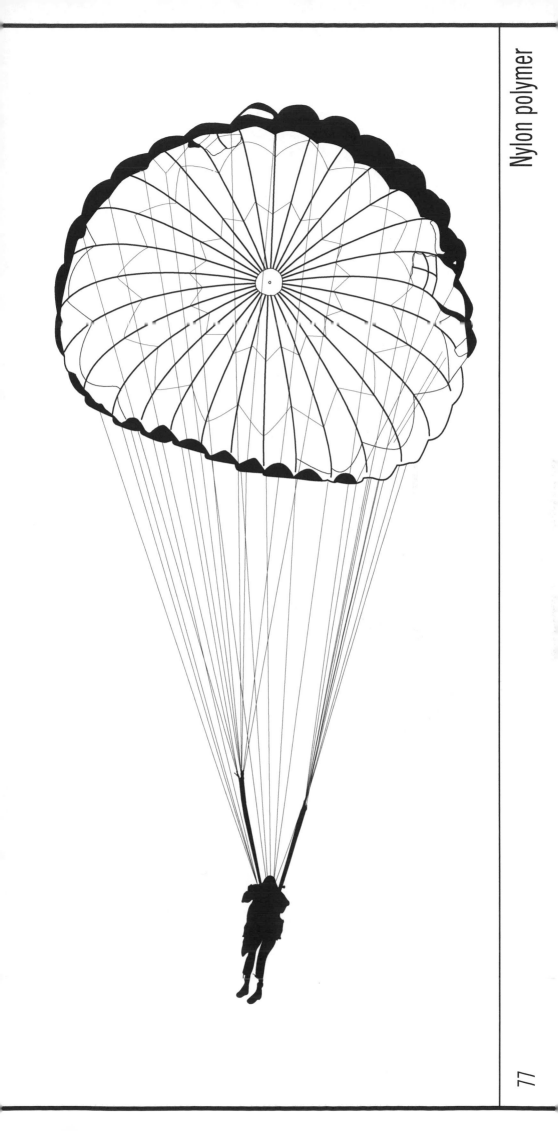

Parachute

Plastic plummeted us into a collective dream, a heritage of magic we thought was dead, coming to life in perplexed new forms. We projected ourselves into plastic's material will to change. Yet plastic is, Roland Barthes notes, "the first magical substance which consents to be prosaic…for the first time, artifice aims at something common."

Twenty days after Wallace Hume Carothers applied for the "fiber 6-6" (nylon polymer) patent, he checked himself into a hotel room in Philadelphia and drank a cyanide cocktail. He had been wearing a capsule of potassium cyanide on his watch chain during the synthetic fiber's development, ever since he moved into Whiskey Acres, a house he shared with three other DuPont scientists, and began buying bootleg hooch from a local mushroom farmer. As a chemist, he knew dissolving cyanide in a citric solution would quicken and intensify the poison's effect. His suicide, on April 29, 1937, took place at the crossroads of the biological: two days after his forty-first birthday, in the first trimester of his wife's pregnancy, less than a year into mourning his beloved sister's sudden death, and several years before the word "nylon"

burst into being. These elements bonded to form a chain of reactions, an exchange of properties. Carothers didn't want children. And the more DuPont pressured him to produce commercial applications of his ideas, the harder he failed to find meaning or inspiration in his work. When we say chemistry, we mean the effort to turn waste into worth.

Immediately following Carothers's patent's approval in 1938, newspapers reported that "one of the ways to prepare the new synthetic silk fiber might be to make it out of human corpses" by using cadaverine, a reeking chemical excreted from decaying flesh. We wondered if Carothers was consumed by his own invention. Just like DNA, nylon is a polymer, but instead of cracking the code of life, it impersonates life. Death imitates life and reinforces its domain. Nylon's 1939 press release sought a rebirth of its image—"wholly fabricated from coal, water, and air" yet "fashioned into filaments as strong as steel, as fine as the spider's web"—and heralded the nylon stocking industry. We marveled at nylon's image of infinite transformation; we titillated slightly at the whiff of death coming off nylon's parade of uniform legs. As the United States entered World War II, DuPont shifted its nylon production from consumer to military use as a replacement for Japanese silk. In 1940, 90% of DuPont's nylon went into stockings; by 1942, all of it went to parachutes and tire cords. Women donated used nylons to be reprocessed as parachutes for Army fliers. Barthes writes, "Plastic is wholly swallowed up in the fact of being used: ultimately, objects will be invented for the sole pleasure of using them. The hierarchy of substances is abolished: a single one replaces them all." Barthes' essay ends on the image of a "plastic aorta." For a human who wishes to strut or fly, a stocking or parachute is also a prosthetic. In rituals of courtship and warfare, nylon extends the body. We grew accustomed to our amended bodies. We saw our futures through cartoonishly gendered parts, if gender is the extent we go to be loved.

In August 1945, just a week after Japan's surrender, DuPont launched an aggressive promotional campaign for nylon stockings that headlines succinctly echoed: "Peace, It's Here! Nylons on Sale!" Loaded with the allure of scarcity and sacrifice during the war, nylons now promised a return to domestic affairs. When DuPont couldn't come close to meeting the demand—10,000 women gathered outside a store in San Francisco, 30,000 lined up in New York; 40,000 in Pittsburgh for a mere 13,000 pairs—the Nylon Riots erupted. For nine months, shoppers smashed showcase windows, they shouted, punched, and pulled hair, they fainted in the push. This brings to mind a parachute malfunction called the "Mae West," in which suspension lines contort the canopy into the shape of an enormous bra, blown against the skirt. The nylon heats, fuses, and refuses to open.

COLOR
ITEM NO.
REMARK

Plastic Flower

a very loose translation of Gabriela Mistral's
"The Air Flower"

The flower who has never seen a meadow says to me: "I want to see the alpine lilies that resemble little snows, softly surviving." I climb the mountain of half-sleeping, half-waking stone to where the lilies ghost. By the roots I pull them for the flower queening in her waterless vase. In a white delirium I avalanche her with lilies. She says: "I want the flushed red flowers." Mountain goats watch me clamber up the crags to where red columbines live and die of red. I give them to the plastic flower, who wears them like water that a wounded deer has walked through. She says: "Yellows, yellows. I have never seen a meadow." Near a glacial lake I find dense morning suns on stems, golden asters newly born and already dying. Will the plastic flower live forever? I pant back to her and in a second delirium drench her in light. What is light to a burst of nylon polymer? She says: "Find me flowers that have no color. I have never seen a meadow." The flowers she wants don't hang in juniper branches and don't push themselves out of boulder cracks. I scissor them from sugared plastic and tell myself that I am blind. I cut plastic from plastic drinking plastic from the plastic forest. When I come down my queen is walking like a sleeper, bending and weaving through a meadow on fire. I can't stop cutting plastic from plastic as I follow her. She has no face when she walks in front of me. She leaves a warm smear. I'll follow her between the grapevines of toxic smoke until she frees me and my petroleum prayer dissolves.

Sacrament

When the woman saw Jesus, the sentimental sorcerer she'd heard so much about, the one who could charm the salty air and conjure nourishment from sawdust, all she could see were his lips, plump and hopeful as a baby's cheek. The man appeared fatigued, worn thin from the exhausting labor of supernatural kindness. Throughout the nights, mouths floated above the woman, small, greedy absences seeking something to swallow, and she gave them her throat, a breast, a tongue and watched flesh dissolve in the ravening darkness, but every morning the strewn remains reassembled and bid her to rise.

Here now before her, hanging in the wan light of evening, was an authentic mouth, the first, that caused her body to swarm inside its throttled longing, a mouth whose infinitude meant she needn't die of the creeping infections of men, and she fingered her skin in search of a sacrifice. She stepped toward the man, his hand falling through the air like a swallow, a star, the eyes of the imminent dead.

Deep in her abdomen she felt the decisive tug of an impulse and she bit down on the inside of her lip, which had the pleasing resistance of the flesh of a melon. The blood she tongued onto her lips, and she felt the redness spread, her mouth opening, like the wounds she knew this man was destined to die of. No heart that tender could be allowed to beat for long in a world where such an organ, properly seasoned, was a delicacy. The woman had always regretted having little appetite for slaughter—it was a failing a body had to conceal in a place where blood runs like wine—and so she kept her eyes to her feet as she walked through the whetted rubble of the world.

The woman pressed her lips together, distributing the blood, and she strode toward Jesus as he stood cleansing the brethren of past sins and the wicked deeds they had yet to commit, her eyes fixed on the calefaction of his mouth.

When finally she grasped with her own the controversial tongue, she saw the world that would rise up in the wake of this one: the saved world that had heedlessly survived both paradise and a creator's volcanic love, the world whose very weather would turn mutineer, the world that would one day systematically evict all its animals, the one whose poisoned sky would be uninhabitable by clouds and whose diluvian moon would last be seen dimming above a boiling sea, this new creation a habitat fecund with sorrow, which, the woman suddenly understood, is the very victual upon which any deity necessarily must feed.

The man's stained lips murmured, undulated like water, and she saw then that the mouths of men, those that would gather above her again tonight, would be no more charitable, no more satiable, no less empty than before. Indeed, she saw in this man's darkening mouth, could hear in the vacant mummery, the desolation of salvation, and with her hair she wiped from his mouth the body she had broken for him and sucked the sacrifice from her lips.

Sacred Heart of Jesus

LIP THERAPY

Vaseline TRADE MARK ®

Lips

SOFT & SMOOTH

FOR ANIMAL TREATMENT ONLY

CAT-LAX
Feline Laxative

A palatable formula for use as a feline laxative.
Aids in the removal and prevention of hairballs in cats.

ACTIVE CONSTITUENTS:
White Soft Parafin 31.1 g
Beeswax yellow: 2.1 g

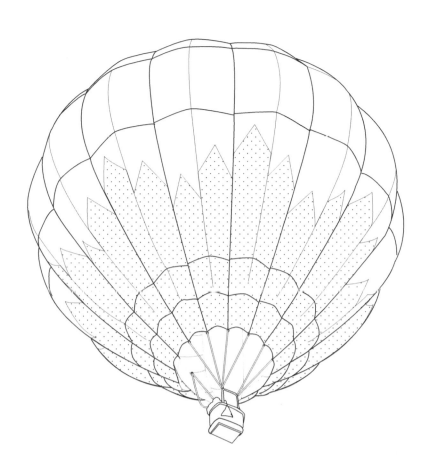

After

What was left? An enormous collection of transparencies. We couldn't be more minimal. That plastic cup, including the ice. Your lenses. A stack of tracing paper, also tracing paper in the wind, and wind. Think of the bottles and bottles of water. Including thinking. A matter of clear glass versus clear plastic, vs. gin vs. vodka vs. tap vs. Voss. A room with two doors in shotgun fashion. I'll stand in this one. I couldn't care less. It looks like static coming down hand over fist. Now, if you stood in that opening you'd ruin it. You can't even come in because of the enormous collection wobbling invisibly.

Sails, Hull, Jibs

She was eating an enormous salad at an outdoor café at the marina. Every few bites she bent under the table to re-arrange a folded napkin under one of its three feet. She added a bottle cap under a second foot. The third foot hovered. Then she scooched the table around on the cement. She took another few bites of the salad, which loomed like a mountain in front of her. She could see her knees through the mottled glass tabletop. The top wobbled in its white metal frame. She looked around, feeling the edges of panic. A boat made a shape against the sky, a triangle with potential dimension. Everyone seemed happy as bunnies. Bunches ate, clinking glasses. She turned sharply in her chair, this way, and then the other way. A few people looked up. Her breath felt like a train. More people looked up. A boat went by. It was a marina on the harbor and still she could see only one boat. It went by, sails gushing, and by the time she couldn't see it anymore everyone in the café had turned to watch her as item by item, signposts, trashcans, pedestrians, and then, plank by plank, the pier, disappeared until she was sitting with her salad in a desert at the ocean surrounded by nothing but suspended eyes.

CD-R

Plexiglass Chair

1.

Ah, the innocence of the chair. We call it an object, which makes it sound less important than jackals, janitors, or Jar Jar Binks.

Chairs. They just sit there, and you sit on them. But have you ever considered the afterlife of chairs? Their life after humans, that is? And their life despite humans? Consider:

—After humans have become extinct, there will be clusters of chairs.

　　—There are always more chairs than people in a space.

　　　—Design 101 classes teach you to design a chair.

　　　　—Chairs shorten human life.

　　　　　—Humans have become chair vectors.

Like a virus, a chair can't reproduce on its own—it needs a human being.

A human is a chair's way of propagating itself throughout the Solar System.

For a long time humans squatted or sat in the lotus position, or whatever. Then conquering armies got it into their heads to sit on their vanquished foes. From this arose the chair—first for the king or emperor, but gradually for their cohorts, and now, in our democratic age, everyone must have a chair. I have a chair, therefore I am a citizen.

Take a stand! A stand against the chair!

2.

The mindless extraction of more and more oil intersects nicely with the mindless reproduction of more and more chairs.

The illusion of plexiglass materialism: some infinitely ductile goo underlies this world. A squirrel is a certain extrusion of ductile goo. A pine tree is some kind of specially formed ductile goo. An iPhone is made of goo. A plexiglass chair is made of goo. This is the old, old-fashioned Aristotelian theory of substances and accidents: flavorless lumps, decorated with colors and other properties like cupcakes.

This default view has persisted way past its sell-by date: the later eighteenth century, when Hume and Kant explained why one couldn't just go around saying whatever one likes about what a thing is. Contemporary thought and science depend on this revolution. It isn't accurate to say that some kind of goo underlies squirrels, chairs, and trees. Yet this view—things are made of matter and matter is gooey "stuff"—gets taught in primary school.

As we now know, when you look closely at squirrels, you find all kinds of things such as cells and behaviors and cultural representations and evolution. And yet a squirrel is not a strand of DNA, nor is a squirrel a poem about a squirrel. Happily we moderns are prevented from saying that a strand of DNA is more real than a squirrel, and that this more-realness consists in being more constantly present—a move some philosophers call the *metaphysics of presence*.

But a plexiglass chair looks like it emerged, one fine day, from some underlying transparent goo. It is metaphysics in chair form, the metaphysics of presence available for delivery from Ikea.

Like elections, philosophies have consequences. "All of the buildings, all of the cars, / Were once just a dream in somebody's head" (Peter Gabriel). Goo philosophy is happy nihilism in chair form.

The smiley face nihilism with which I seem to be able to dissolve the world into its constituent goo, and reconstitute it any way I wish. All of us moderns—that is to say, post-Kantian people, and people living in the Anthropocene (a strange coincidence: both began in the late eighteenth century), are like members of the Bush Administration, who described themselves thus: "We're an empire now, and when we act, we create our own reality."

It really is strange, that coincidence of Kant, who began to drive the stake of modernity through the heart of metaphysics; and the Anthropocene, driven at first by the steam engine, with its fearsome geophysical impact and that of its successors. The world was demystified, clearing the way for modern science. At the same time, a default metaphysics of presence—reality is made of some kind of gooey stuff, like

thermoplastic—was hardwired into modern life. With the best of intentions. Who doesn't want to live? Make more children? Sit in a nice plexiglass chair?

The view of reality as plastic goo I can manipulate just as I wish predates thermoplastics. The Industrial Revolution happened because of the Agricultural Revolution. The Agricultural Revolution happened because a certain form of agriculture had gone viral, for ten thousand years—the one that arose in the Fertile Crescent: the world around humans is a standing reserve of stuff that I can fence off just so and plant what I like on—and let's eliminate the "weeds" and "pests." Let's make it as uniform as possible. Smooth, like a plastic chair. Result: Population explosion. Patriarchy. Massive social division. Environmental diseases.

Geology shows that in the last 10,000 years there was an unusual periodic cycling of Earth systems. It was a direct result of these agricultural machinations. Machinations that generated the need for the revolutions by which the cycling collapsed. Now we live in a world of disconcerting spikes: the Anthropocene, with its global warming.

Some call this cycling Nature. But after the spike, we can come to another conclusion.

Nature is a plexiglass chair.

"A Camera's Not Expression, It's Part of the Spectacle": 5 YouTube Videos

Toronto

"So, seriously if you wanted to get out you would get arrested." She's sitting in the intersection with about 60 others, surrounded by cops in riot gear. They begin a slow advance. Someone spits. "Fuck you!" a woman yells. Someone spits again, and the cops come on, batons out, shouting "Move!" Officer 11909 slams his shield into him, opening a cut over his left eye. "Fuck! Where the fuck am I supposed to go!" "Are you okay?" she asks. "Asshole," someone shouts. "Are you fucking kidding?" He puts a hand out. "We're fucking people! We're people! What's wrong with you?"

Tegucigalpa

She trots her torta cart through a crowd outside La Fogata, tear gas erupting a block away. They're chucking stones, firing slingshots. He crosses carrying a tripod. These cops are huddled on the corner, holding their shields together in a protective wall. He throws a rock back at the boys coming across the median, getting bolder, forty yards away, twenty. Now something's burning back there. Now a Molotov's exploded where the cops were and they're backing away, scattering in a disorganized retreat, the boys advancing, accelerating their bombardment accompanied by a wailing guitar and Brigadier Ambrose shouting "POLICE! POLICE! POLICE!"

Oakland

"You're being recorded!" They've formed their own line. Handmade shields spraypainted with peace signs, anarchist A's. He's crouched behind a red wingback chair. Flashbangs, tear gas, breaking glass. The Asian kid ducks, turns instead of snapping a pic. They scatter, fall back. Car alarm. "If you do not disperse you may be arrested!" She holds her hands to her ears. He's checking his camera's LCD. He's taking another photo. "Fuck you!" Ski helmet, goggles. "There's nothing peace about you!" We're dollying backwards, following him retreating with his chair, recording with his phone. He lifts the chair, hugs it, exits right.

Ankara

Pops and hisses. Gas. Shouts and whistles. Breaking glass. Stones pelting shields. These cops are backed against some concrete chairs, public art. Hands up, he tries to calm the crowd. Five cops run. The others collide. This one drops his shield. That one falls down. They escape as protesters swarm the spot, hurling stones, waving red banners. Burberry scarf. Striped conical hat. He's toting a red crate. One cop's limping, supported by another and a man in jeans. A wall of appropriated shields advances, one spraypainted with an anarchist A. They pose for the photographer. Two peace signs. One fist.

Brussels

Red sweatshirt, blue ballcap, spraying the second floor windows with a fire hose. A photographer. Echoing pops. Drums, shouts, cowbells. Now they're hosing down the cops ranked behind barbed wire in the glass-walled plaza, curved walkway overhead. Not water: milk. A fire by the line of bikes. Tires, green gas can. Horns, whistles. Now they're dragging away the barrier. Milk films the cops' faceshields, blinds them. He lunges forward, swings his baton over the wire, doesn't connect. That guy in the grey jacket has fallen. He rolls away. The cops pull the wire back into place. Here comes the milk.

The Fish That Was Not Just a Fish

There was a fish that was not just a fish—for yea, verily, this fish was also a prophet. This was eons ago, back when the world was young and a prophet was a thing you could be if you wanted to, even if you were a fish. Except to put it that way is not quite right, for it has always been true that prophets do not choose to be prophets. Nay, they are chosen.

The prophet who is the main character of this story was named Brbtbtbpppccdddddffttffffddbr, but for the sake of the narrative's forward momentum we are going to call him Bill. Bill was an ugly fish, even by the standards of the hideously bulbous species of bottom feeder of which he was a member. With Bill, all the usual bulbousness was there, but it wasn't in the right places, if that gives you any idea. Poor Bill: as a young fish, he was ostracized for being so ugly; no female would even for a moment consider leaving millions of her eggs around where Bill might find them. And then, as he reached his maturity, he was ostracized for having been ostracized earlier. They were an unforgiving lot, these bottom feeders.

Which was too bad, because had they taken the time to get to know Bill, they might have discovered what a rich inner life he had. Not that he didn't try to tell them about it. "I'm having a lot of feelings over here," he would say, or "It's like my bones can see colors." "What do you mean, colors?" said the other fish, for color was a concept that wasn't available to their species. "I don't know," Bill would say, which was true. The other fish would laugh at him and then blink their cold eyes and say, "Go away now, ugly one."

As his powers developed, Bill's inner feelings became less like run-of-the-mill feelings and more like prophecies. When a bad thing was about to happen, or a good thing, or a thing neither bad or good, Bill felt it in his bones, and he tried to tell the other fish about it. But of course they wouldn't listen, and even when it was obvious that he'd been right they wouldn't acknowledge it. After a while, Bill stopped sharing his prophecies with the others, who immediately began teasing him for having lost his gift. Bill just leveled a blank stare at them and thought, but did not say, You are all beneath me. (Among bottom feeders, "You are beneath me" is a terrible insult.) Yet in his heart of hearts he would have liked nothing better than to be welcomed into the school.

So ends our preamble. One day—a day not otherwise different from other days—Bill was given the greatest prophecy of his life. Here is how it happened. He was swimming along by himself, as was not only his habit but also basically his only option for a thing to do, when suddenly every bone in his body went electric. He got such a jolt that he lost control of his movements and banged his head against a rock. He came to rest in a soft, muddy area as his bones went on sparking. What were they trying to tell him? Was something terrible about to happen to one of his fellow fish?

Was there a particularly rich cache of rotten plant matter just around the corner?

No, his bones said, it's nothing like that. Listen up, they said. In the eons to come, after you and all your kind have died, you will be, over a long time, pressurized into a rich, dark ooze. Long shall ye slumber—long but not forever. For a new breed of creatures of the land will covet you. They will seek you out and find you, bring you from beneath the waters and, after refining you into something they find less crude, burn you. Thus purified, your souls shall rise up into the heavens, where, because of the sheer number of them as well as the special qualities they have, they will alter the destiny of the entire globe. In other words, you will become like gods, all of you, albeit essentially passive gods.

At this, Bill's bones fell silent. He lay there on the muddy seafloor, gasping for water and trembling from his lips to his tail. A new feeling was jolting through him. Somehow, although he'd never experienced it before, he understood that the name of the feeling was happiness. Bill was happy! For yea, sure, it would be many eons hence, and Bill wouldn't even be himself anymore—it sounded as if he was just going to be part of some kind of generalized ooze—but still, if he understood the prophecy correctly, the day was fated to eventually arrive when lo! Bill, the ugly one, the unwanted one, the one who at this moment was lying alone in the mud, no one to tell his good news to, yea, that very same Bill would at long last come to know, and not a moment too soon in his opinion, what it was to be desired.

UPPER LEVEL

LOWER LEVEL

Perpetual Pastoral

The Fisher Price® cups we children dropped
in brooks as boats have made their way by now beyond
the corrugated, plastic drainage tubes we lived to see
them through, channeled underground and out
again, into larger streams and rivulets,
past the factories (such picturesque
remnants of a certain, hopeful industry)
and down the Hudson to the Dutch Antilles,
or even (I swear I see them there) the background
of Monet's "Soleil Levant"—messengers
of the Technicolor age, unsinkable misfits of truth
and trashiness that gleam endlessly, like fake grins
in photographs, but intoxicating and literally endless.

Immortal

People say I have a disorder. The medical name for it is a Pica, which is the Latin word for "magpie" because magpies eat anything, but actually I don't. I only eat plastic. So I don't have the Pica disorder. Plastic is just who I am. I would not eat a magpie, unless it was plastic.

The first time? When I was a baby, of course. I was teething and crying, and Mother put a plastic nipple into my mouth to pacify me. Ever since that moment, plastic has the power to pacify and soothe me when I am upset and crying.

Toothbrushes were next, but I didn't used to eat them. I just chewed on them while sucking on their fresh and minty flavors.

I remember the first time I swallowed. It was a Bic pen, the ballpoint one with the conical cap. The proper name for that ballpoint pen was the "Bic Crystal," but nobody remembers that name anymore and now everyone just calls them Bics. Mostly Bics were blue and red and black, and sometimes green, but the first one I ate was blue, and ever since I've found blue to be the most delicious.

Blue...with that irresistible prong that keeps the pen upright in your pocket. I used to chew on that prong until it was mangled and flat and as thin as paper. It was my challenge, to see how papery thin I could make it by biting and tapping on it with my big front teeth. Sometimes little slivers break off, and at first I used to spit them out, but when I got in trouble for spitting I started swallowing instead, so the sensation of swallowing became part of the challenge, bringing a kind of satisfaction and a hunger for more. Soon I was eating the whole prong and then the whole cap, too.

There's a little plug at the end of a Bic with a sharp flat cap and a short hollow stem. You can press your tongue against the plug's little hole. If you have a clever mouth, you can suck the air out and make the plug stick to the tip of your tongue using suction. If you still live at home, you can wiggle your tongue with the plug on it at your baby sister and make

her laugh. The plug is especially delicious on account of the smell of the ink that clings to it. The ink tube is even more delicious. It is delicate and pliable and chewy, but it makes the inside of your mouth go all blue, which can get you in trouble with your aide if you're not careful.

The chewy parts of a Bic are the cap, the plug and the ink tube. They are made of polypropylene, which is a semi-crystalline plastic. The hard and brittle parts of a Bic are the long barrel that is hexagonal like a pencil and also the point, which is also called the nib. The hexagonal barrel is made of polystyrene, which is completely amorphous. I love these words: semi-crystalline and amorphous. (The nib, or ball point, is not made of plastic. It is made of a vitrified metal called tungsten carbide, which I would never eat. I spit out the point, which has the ball in it.)

The first time I ate the barrel of a Bic I was surprised at how brittle the amorphous polystyrene texture was. It's hard to describe. You have to use your back molars to crunch it, but when you do, it splinters into small shards that leave a very satisfying feeling in your mouth that keeps changing as you chew.

CD cases are also made from polystyrene, too. So are plastic knives and forks, disposable cups like you get on airplanes and plastic food containers. I like to eat all of these things. I also like the following: buttons, beads, soda bottles, water bottles, bottle caps. Combs, ear buds, ice cube trays, sunglasses. The round dome-shaped lids from a Starbucks iced latte (as long as there's no milk foam stuck to it). Clamshell packaging, plastic soldiers, TV remote controls (with nice rubbery buttons), cocktail swords (the kind they use for olives, but I never eat the olives), credit cards, computer keyboards, my brother's football helmet. Plastic flowers (sometimes I am allowed to go into a dollar store, where I can buy a bouquet of plastic daisies for a dollar, and then later I can eat them in the park. I have to be careful to eat only one or two, or else they'll notice and I'll get in trouble).

Fly swatters would be delicious, too, except for the fly guts, which are gross. Lawn furniture. Sometimes, in the waiting room, I think the molded plastic chairs look delicious, and when nobody is looking, I will lick them.

I tried to eat a balloon once, but it was too chewy and I was afraid of asphyxiating myself so I spit it out. You could say I had a panic attack. Same with plastic bags. Too shapeless and baggy. Too imprecise.

Once I ate a kitchen timer. It was shaped like an egg. That was super-precise.

There's precision in eating plastic. It's clean and tidy. They say you are what you eat. I do not like to eat organic matter. I do not like to eat big living things. Big living things are gross because they go rotten. Vegetables, like stinky broccolis, are big living things, even if they are as small as squishy peas. Meats are not living things, but they are only recently dead. Not dead enough. I only like eating things that are small and hard and have been dead for long enough to be purified by the forces of heat and time and pressure. Plastic falls into this category. Plastic comes from tiny, precise organisms—zooplankton and algae—that have been dead for a long long time. That's perfectly dead, in my book. Safe. Super-clean. Pure. Immortal.

IV Bags

If it's true that we are held up by nothing but neutrinos falling down on us from the future from which they emerged, then the IV bag holding you up, today, my daughter, is the sign of that black hole collapsing. Oh the substance that drips through tubes into you. Let it be more matter than anti. Let it be more light than darkness. Let it be more quantum than gravity. Gravity will only take you down and this IV bag will help you rise up. I would give anything for you to rise.

My job on this planet is to reach toward the tube, hold its fleshiness between my fingers. I should squeeze the tube for just one second. I should make sure the fluid that drips from the bag drips in sunny quotients. I will work as hard as gravity works.

Your whole life has been attended by plastic—incubator, gloves, syringe, mask, cannula. The plastics have been watching you. They keep you tethered to this ground, this light, this gravity. It is only when my fingers ache from the pressing, when your eyes film over with their own oily substance, when blood pressure plummets and you turn red all over from what may be an allergy not only to latex but to all plastic, and thus, nearly this whole earth, that I wonder if I should let the black hole have you back, that the neutrinos flowing through you should flow the other direction, that gravity and the IV bag and its tubing should let you go. *Don't go.*

Plastic. I promise. You will get used to it, your life depends on it. The rash on your arm from the tube rubbing against you as it hitches into your hep lock is a rash to which we all become accustomed. How else to keep the groceries safely ensconced? You will love cherries. Blueberries in their clamshells. Fruit is the opposite of galaxy and a reason for this long-term commitment. *Plastics Make it Possible®,* even love possible, if you need it to. My hope is, as I shake the fructose through the line, that the slogan also applies to you.

The Story of Oil

When I was a child, I had a book—a book that was already old, a relic. *The Story of Oil.* In the book was a drawing—I know it must have been a drawing, although in my memory it is as vivid as a photograph: the landscape is rendered in the soothing, alien palette of Pleistocene dioramas—ochre skies and yellow grasses. In the center is a vast lake of tar in which Strange Beasts of the Past (another book—another story) are trapped, struggling against an inescapable destiny— which is to become the engine and essence of the inevitable present. A gentle giant of some sort (a mastodon? a giant sloth?) whose only crime was mistaking death for drinking water, struggles to lift her feet, her eyes filling with a deep pooling sadness as relentless as the tar itself. Riding her back is a tigerbeast, as opportunistic as a pickpocket—angry and snarling, trapped by her own greed. The image is a parable, a gazing ball through which the entirety of evolution is revealed as not only pointing to "us" but to the combustion engine. Decoded correctly, any child can see that the reason these prehistoric beings lived and died (and suffered) was to lubricate and propel the future perfect present in which we live.

I am stuck in this image, as surely as the animals depicted in it. I think of it often, as it is an image of horror, like a lake in hell. Perhaps this is because this image is a Trojan horse, carrying many agents and messengers. Through this image I am initiated into many "truths": encoded in the DNA of this image is evidence of the cruel suffering caused by the processes of the natural world. This idea of the Cruel Natural World preempts any discomfort one might feel at the evidence of cruel suffering caused by human intervention in the Natural Order…All beings live, starve, suffer and die— we are not a disruption but simply a flavor. In fact, look at this image long enough, and swallow it deeply enough, and it is clear that our appropriation of their animal bodies is a form of redemption—these wooly mammoths, like Christ, died so that we might live.

But symbolic orders are unreliable, and have a tendency to shift, leaving us stranded and floating. Now I am an adult, and I know we do not get our oil from Wooly Mammoths but from phytoplankton (so much more difficult to depict microorganism struggling in lakes of tar—I get that). I also know the bottom is really the top: perhaps we are the ones who live, whose combustible engines fire, so that the phytoplankton (who, let's face it, had dominion orders of magnitude longer that it has taken us to evolve from shrew-like peons) can purge the earth? Perhaps we are only the mechanism to bring to fruition the version of the universe that became locked and trapped in these cells, slumbering like a genie in a lamp until our catalytic converters set it free?

The thing about immortality is that you have to take the long view: to give up your attachment to notions of stasis/

normality and accept the eternal constant of change that eternity means...Perhaps these ancient animals are simply time bombs, correcting for a planet that has become overrun with mammals—particular mammals: bipeds, pants-wearing, gun-toting, phanstasma-philic bipeds full of sentiment and overly sensitive to change.

Seen from far enough away, one has to ask—Why all this sentimental attachment to a blue planet? Think of this process of translating the atmosphere as corruption, and it disturbs...but if you think of it as liberation, from the tyranny of chlorophyll and sunlight, what then? In what unimaginable illustration are we (and by "we" I don't just mean humans, but polar bears, hippos, frogs, bees) suffering so that an unimaginable future can struggle into being?

Immortality means there is always time for another roll of the dice—perhaps there are many ways to be consumed by the inevitable, and being stuck in a lake of tar is only one.

Violent Reactions

The following excerpts are drawn from a transcript of a telephone interview I did on March 24th, 2013 with my father, Joachim (Jim) Kellhammer who worked in a factory near Preston, Ontario that manufactured polystyrene pellets. He quit that job to take another in Cooksville, Ontario to help run a plant that made plastic-fronted concrete blocks which were widely used as an inexpensive substitute for wall tiles in constructing the kitchen areas of McDonald's restaurants. Now 81, he has suffered from non-Hodgkin's lymphoma and colon cancer, but is currently in remission from both. Dad volunteers at the Credit Valley Hospital cancer ward in Mississauga, Ontario one day each week.

Part I

O: Right. So tell me about the plastic factory in Preston. What was your job there?

Dad: Well, I was....When I started there I didn't know anything about anything. So anyway, I ended up as a foreman when you were born.

O: In '59?

Dad: Yeah, so I was more...I was running the reactor room and what happened was we got tank cars from Dow and Polymer Corporation in Sarnia and we had those big storage tanks outside and we had four reactors that took about ten to twelve thousand pounds of styrene each and we pumped this stuff into those reactors but it of course was catalyzed. We had a catalyzer and we had to put butyl peroxide in there in order to speed up the reaction.

O: And that's a catalyzer? The butyl peroxide?

Dad: Butyl...butyl perbenzoate and butyl peroxide.

O: And what did that stuff look like? Was it like liquid or how did you handle that?

Dad: It was liquid. It was actually an accelerator...without this stuff...well we cooked, we cooked the stuff in the reactors for X number of hours and then we baked it and then we put water into the outside of the frames and cooled it off and we ended up with heavy blocks, you know, about two hundred pound blocks.

O: Of styrene....

O: So if it went wrong then, if it didn't mix properly or something—you would have what? An explosion or was it gas giving off—or *what* happened?

Dad: Well it could have been an explosion but it was what we called a "violent reaction." And so, you....It was so powerful you couldn't do anything about it, you know. You just keep on putting water on it and you run around with gas masks. It wasn't very nice I tell you!

Organic life and other myths

Humans have problems dealing with time. Things that took us centuries of technological evolution to develop, whether a complex surgical appliance or a plastic fork, are of interest only as long as they serve the short-term purpose for which they were created. Even those who think about "long term" things like climate change rarely consider time beyond a few centuries or millennia. And yet we are entangled in deep time. Our bodies are the result of stellar explosions billions of years before the sun existed and we have sent out probes that will travel through the galaxy long after we are gone. Our insistence that the scales of time that frame human behavior and cultures are the most important principles in the universe blinds us to the fact that our evolution has comprised just a tiny subset of the dynamic changes that occur even on our own small planet and that non-human and even non-*living* materials undergo their own transformations and evolution in the course of deep time.

Humans have a complex relationship with plastic. As with anything else that permeates our lives, our reaction to it often depends on what it's done for us lately. The HDPE water bottle grasped and emptied so gratefully after a long run on a hot day almost instantly becomes an annoyance and a literal and metaphorical burden once empty, a possible source of potentially harmful phthalates if reused, and decried as near-eternal environmental pollutant if disposed.

Yet plastic is derived from biological processes and undergoes complex chemical and form changes, just within a different time frame than those of living things. Plastic is created from petroleum which in turn was formed over hundreds of millions of years by the breakdown of microscopic organisms. It shares our intrinsic chemistry, but since it is formed from our work and based on our needs, it is created to be stable rather than reactive, taking decades or millennia to be re-shaped by the environment.

Plastic is denigrated as a mere product of manufacturing. But a virus turns our cells into automated factories for making more viruses. Organic molecule-sized nanomotors tied to biological amplifiers underlie our hearing and our muscle contraction. So when a 3D printer takes a filament of acrylonitrile butadiene styrene and outputs a plastic inner ear or the pieces to construct more 3D printers, is that mere manufacturing? Life runs from genetic code to protein expression, building solid living elements from genetically coded plans. A 3D printer does the same, changing code into physical objects. Biological and plastic systems are built and formed from coded information acting on organic materials. In ten thousand years, we may be gone, victims of our own short chemical half-lives and even shorter-sightedness, leaving behind only ruins and what we thought as trash. Will this largely plastic trash, landfilled with partially dead batteries, consumer electronics, sensors and motors, exist only as a sign of our defunct civilization? Or will it serve as

the building blocks for our trans-biological successors? Will some discarded toy rub against a broken solar panel and a discarded iPhone touch *just so* and wonder why there is no one else around to enjoy and build on all these riches and resources?

Anaerobic bacteria poisoned themselves out of existence billions of years ago by flooding the world with their own waste product—oxygen—and giving rise to a world of oxygen-breathing eukaryotic complexity. While humans have feared the golem, the Frankenstein's monster, the vengeful artificial intelligence, the thing that we create that will rise up and destroy us, it seems more likely that we are on the same path as our anaerobic ancestors.

Violent Reactions

Part 2

O: So they were poisonous fumes then....You had to put a mask on to um....

Dad: They had fumes...yeah.

O: Yeah—so [...] did it smell like Styrofoam or what was the smell like?

Dad: Well like—you know how styrene smells.

O: Yeah, a plastic smell.

Dad: Yeah, and your clothes stink and you have to take your shoes off when you come home.

O: Yeah, I remember the smell from when I was a little kid. You used to come home and I could smell the smell. [...] How many people worked there? You were the foreman. Were there lots of other crew?

Dad: We had three shifts because, you know, like you do the cooking for about six hours and then the baking on a reactor and it never stopped. It was a 24-hour cycle.

Dad: And you know the people who owned the factories— they didn't know much about it because [...] they just—they saw the money and saw that they could make a few bucks. In those days plastic was the thing you know....

O: Yeah, it's like that movie, you know, *The Graduate*—plastics were the future!

Dad: Yes, yes.

O: Well and all the little toys, you know, I had as a kid. We used to build those models and they were all made out of styrene. Do you remember that—those little plastic airplanes and everything?

Dad: The many...the many toys....

O: Yeah! It was all styrene and it had the same smell. I remember the smell.

Dad: Polystyrene....

O: Yeah! I remember opening up one of those models those kits, you know, for an airplane—a WWII fighter plane or something—and you would open up the box and it would smell the same as your shoes used to smell and your coveralls used to smell.

Dad: On Queen Street and then we moved to Montgomery. Do you remember the little guy downstairs? Poncho?

O: Yeah, yeah, yeah.

Dad: He was your friend. You used to be on the tricycle together.

O: And you made us a sandbox in the yard of the—I remember that.

Dad: Yeah, yeah. You know what? I used the monomer, the styrene—I killed weeds with it in the backyard.

O: (shocked) Really?

Dad: We had a parking lot there and those weeds coming out all over the place, so I just took a five-gallon can and took some stuff home with me at nights and I dumped it on the weeds and—

O: You killed 'em!

Dad: You could see it die in front of your eyes.

<center>***</center>

O: And that came from Sarnia, from the chemical factory?

Dad: Yeah it came...we got it in the tank cars. We did everything there you know, like we moved tank cars at two o'clock in the morning. You know how to move a tank car which has sixty-thousand pounds of stuff in it? You take a crowbar and go under the wheel and just push it and then when it starts rolling you make sure you're on the tank car, because they didn't always stop in front of the outlet.

O: Yeah....

Dad: And they—you had a brake on each tank car. You just hope for the best. You stop right where you're supposed to stop.

O: Oh god! So did anybody get hurt doing that? It sounds incredibly dangerous.

Dad: Oh it is dangerous. Yeah, well, so I did this job and I never let somebody [else] do it, you know....

O: Oh, I see—that was the *foreman's* job.

<center>***</center>

Plastics and Plasticity:
The Ugly, the Bad and the Pretty Good

Long before humans started teasing long, repetitive molecules from crude oil, anthropologists described human behavior as plastic—a trait recognized for at least a couple of thousand years. Our capacity for altering individual and collective patterns of activity and relations defines us and helps ensure our survival—thus far—but at a significant cost to ourselves and the rest of the world. The lethal legacy of plastic is only a recent, ugly ripple we have set in motion that is extinguishing so many of our covoyagers. The malleability of oil is matched only by our own malleability.

Plastics are a consequence of our relentless scratching about for energy subsidies over the last dozen millennia. Fire for cooking, heat, and speeding up grassland succession; domestication of plants and enslavement of animals; gravity irrigation and water wheels; new soils to replace exhausted ones; human slaves, serfs, and wage-slaves—all like oxen, producing more than they eat; colonialism; neocolonialism; coal and oil; river-killing concrete monoliths, split and fused atoms. We count in dollars or Renminbi but are really seizing more and more calories—the currency of nature's economy—and depriving others of those calories. Control of energy enhances the ability to get more of it just as it magnifies our plasticity.

Energy subsidies allow us to colonize ecosystems and other species the same way one country does another, reshaping the colonized to the purposes of the colonizer. Inevitably, the colonizer is deluded into thinking they are wise lords rather than a drunken bull in a china shop. Control of energy reinforces hierarchy and centralized technology, and allows some states and corporations to manage the lives of billions in ways despots of old could not have imagined. We reach into intact rain forests for the substances to make our cell phones and impose a death sentence on creatures once safe from us—phones which tell the police *Here I am*. Our plastic computers tell our commercial masters which of our buttons to push to make us buy and keep buying.

Today even the grandiose have fallen on hard times—Saddam Hussein's many palaces turned out not to be made of marble and granite but plastic. Disneyland comes to mind, where faux mountains are constructed—tame, simplified, above all "safe" in some superficial way. But neither our plasticity nor plastics are safe.

Our plasticity is one and the same as our capacity for alienation—they are like the twin threads of DNA. We make bad deals with the world and say it is good. But we can't hide—what we do to the Earth we do to ourselves. Our plasticity means the plastic isn't just out there, it is in us. "This is what is the matter with us," D.H. Lawrence wrote toward the beginning of the age of oil and plastics. "We are bleeding at the roots, because we are cut off from the earth

and sun and stars, and love is a grinning mockery, because, poor blossom, we plucked it from its stem on the tree of life, and expected it to keep on blooming in our civilized vase on the table."

Along with the truly ugly and worthless, the simply bad, the stupid and pointless toys, and some worthwhile things for which there are non-plastic alternatives, there may be at least one plastic device which borders on the redemptive. The Center for Biological Diversity distributes them free, admonishing us to—

Wrap with care…save the Polar Bear.

Use a stopper…save the Hopper.

Don't go bare…Panthers are rare.

When you're feeling tender…think about the Hellbender.

Be a savvy lover…protect the Snowy Plover.

In the sack…save the leatherback.

Potential: A Questionnaire

1. Imagine that you are a single heterosexual woman in your late 20s. You have just had sex with a single heterosexual man in your own bed, having adhered to the solution (number of dates) of your own personal equation considering the variables of desire (x) and the perceived social norm of your peers (y). After brief discussion, the two of you judiciously elected to use a condom, his brand, the Trojan Supra (which sounded more like midsize car than what the label assured you was a premium microsheer lubricant condom, though you kept this observation to yourself). Which of the following disposal methods is most attractive in a prospective mate?

 a) he feigns (perhaps) the need to urinate; in the bathroom, he neatly wraps the condom in a tissue and tucks it in the wastebasket beneath a flattened box of Advil and three nail polish-stained cotton balls

 b) he drops the parcel damply, delicately on the floor beside the bed, leaving it there like a forgotten party favor

 c) he ties off the condom, for tidiness and/or aerodynamics, and, making certain that you are watching, he flicks the condom in the direction of the metal Hello Kitty waste can sitting beside your dresser

2. To what off-label uses have you put a condom?

 a) smuggling an illegal substance into the U.S. via your abdomen or rectum; you were young; you lived by your wits and your orifices and organs

 b) microphone protection; your employer/hero/lover/candidate was about to give an outdoor speech under darkening skies (the story of your life)

 c) as costumes in a late Sunday afternoon finger puppet show for your twin eight-year-old niece and nephew

 d) to keep soil samples dry during field work in Colorado

3. When you hear the word "condom" the first thing you think of is:

 a) water balloons

 b) performance anxiety

 c) the Bill and Melinda Gates Foundation's "Grand Challenges Exploration 11"

 d) your bleak, childless existence

4. Imagine that you are a single heterosexual male in your early forties; you have just had post-dinner-date carnal relations with a woman (OKCupid profile name Loves_Men, actual first name Jean or Jeanie) in the backseat of your Volvo; you supplied a joint and a half-flask of tequila and she supplied the condom. Having served its very important purpose (you assume for the moment), the condom is now a logistical problem. You:

a) insouciantly drop the cum-filled sack into the cup holder between the two front seats

b) this scenario is simply too hard to imagine, any of it: wedging yourself in the backseat, let alone with another person, being out past 11, having sex with a woman, an indifferent woman, a loose woman, a fertile woman

c) pull your pants up over your chilled ass and flaccid penis and wiggle your upper body into the front seat and fumble around in the glove box for a fast food napkin in which to wad the rubber, replacing the package in the glove box

d) do what you always do: tie a swift knot and chuck the damn thing out the window; you have done your public health duty; you have maintained your pledge to not reproduce; what more could the world want from you?

Taxidermy Forms

We were in the waste, a box of Pampers, an injured hound, and a life raft, though we were in the desert, it was a desert, the waste. Why did we have the raft? Would it find a new leg for the dog, would it find the baby for the Pampers? The baby was named Decimal, and she was taken by the whispers, the ones that blow across the sands of the city.

*

Pampers, a hound, and an inflatable dinghy. Something is going on with the hound, it is missing a leg and has no tail. It is like a gristle of pain, this hound. A sack of Pampers is the antithesis of pain but it's there for sure. And the dinghy, is it for rescue or is it just to mess around with in the waves.

*

We remember the waves, we remember the way they used to caress our ankles. We remember the baby, Decimal, thinking about the waves then splashing around in them for the first time. There are some of the same materials used in a diaper, an inflatable raft, and the materials used for a hound that has suffered.

What Does Calm Say

Spring snow comes softly into the tiny mountain town, from the canyons, which have already turned opaque. A church bell is ringing, anachronistically. No suicide bombs, no gang rape, no nuclear winter, no drone strikes, no polar extinctions. Just a village buried in inconsequence. As if it were a dream we can't re-enter. In the beginning, the authors say, the world was black and white, before the clay wrapped itself around itself, forming an inside and outside. Hole in the bedrock where the water breaks. Dear Sister Outsider. Our Lady Underground. Atmosphere, a ripped frock the shade of swans. We know the soul can become unbalanced, out of tune like a guitar, that snakes and rats will leave their holes when they sense disturbance in earth's core. What does calm say, sinking into its dark-skinned ditch? What does peace say, in the continuous line-making of its horizons? What does oil say, the figure we have chosen for our voice?

[]
GLYCOL

If it's true that we are held up by nothing but
neutrinos falling down on us from the future
from which they emerged, then the IV bag
holding you up, today, my daughter, is the
sign of that black hole collapsing.

[]
POLY

…as boats have made their way
beyond…

A
POLYACRYLONITRILE

how the ground seeps
what millennia keep

A^2
STYRENE

And when the floods rush in,

C
HIGH-DENSITY POLYETHYLENE

I blamed myself even though I knew better;
why was I keeping such precious things in
my apartment?

E
AMMONIA

What? No one's down there.

E^2
METHYL

I was deeply fixated on the item, which I
fondly called a "zaza," and I still remember
the last zaza I owned, which I finally lost
and which was not replaced by my mother
despite terrible wailing.

E^3
POLYISOBUTYLENE

After humans have become extinct,
there will be clusters of chairs.

G
POLYETHYLENE

Near a glacial lake I find dense morning
suns on stems, golden asters newly born and
already dying.

H
METHACRYLATE

The polystyrene container that held our take-
out food is instantly demoted to landfill trash
and a perceived potential source of carcino-
gens within seconds of leaving our hand,
bound for the polypropylene garbage can.

I
POLYPROPYLENE

He grabbed the birds from their cages, or
scooped them up if they were chicks, and
held them up for the crowd to see.

I^2

POLYVINYL

Not to scale, each drawing lacks a sense of
ready function: how it plugs into technical
systems with their humans, puddles, and
toilets.

L
TEREPHTHALATE

But our plastics will live forever, no longer
able to decompose, while we become
molecules again.

M
NYLON

As the United States entered World War II,
DuPont shifted its nylon production from
consumer to military production as a replace-
ment for Japanese silk.

M^2
PROPYLENE

Well it could have been an explosion but it
was what we called a "violent reaction."

N
POLYMER

Nurdles are tiny plastic resin beads, micro-
plastic precursors to *things*.

O
CHLORIDE

The instrument, invented by Athanasius
Kirscher around 1650, was designed to be
played by a breeze.

O^2
PARAFFIN

Spring snow comes softly into the tiny
mountain town, from the canyons, which
have already turned opaque.

P
ACRYLONITRILE

At the housing store to buy more girders,
Tyler saw the display: cross-stacked bags
of Super Turf Builder® with Plus 2® Weed
Control, piled so high he couldn't see the top.

R
BUTADIENE

They will memorialize our absurdities (rubber
chickens) and our advances (rolling suit-
cases), our necessities (Pampers) and our
superfluities (Pampers), our hopes (silicone
butts) and our fears (parachutes).

S
POLYSTYRENE

The woman had always regretted having
little appetite for slaughter—it was a failing a
body had to conceal in a place where blood
runs like wine—and so she kept her eyes to
her feet as she walked through the whetted
rubble of the world.

S^2
POLYURETHANE

It seemed as if the entirety of evolution
was not only pointing to "us" but to the
combustion engine—that the entire reason
the beings of prehistoric eras lived and died
was to lubricate and propel the future perfect
present in which we live.

T
ANHYDROUS

...cheery blue ribbons snapping out
from the wind...

T^2
POLYPROPYLENE

Such is my dinner.

P At the housing store to buy more girders, Tyler saw
the display: cross-stacked bags of Super Turf Builder® with
Plus 2® Weed Control, piled so high he couldn't see the top.
E What? No one's down there.

T ...cheery blue ribbons snapping
out from the wind...

R They will memorialize our absurdities (rubber chickens) and our advances (rolling suitcases), our necessities (Pampers) and our superfluities (Pampers), our hopes (silicone butts) and our fears (parachutes). O The instrument, invented by Athanasius Kirscher around 1650, was designed to be played by a breeze.

[] If it's true that we are held up by nothing but neutrinos falling down on us from the future from which they emerged, then the IV bag holding you up, today, my daughter, is the sign of that black hole collapsing. C I blamed myself even though I knew better; why was I keeping such precious things in my apartment? H The polystyrene container that held our take-out food is instantly demoted to landfill trash and a perceived potential source of carcinogens within seconds of leaving our hand, bound for the polypropylene garbage can. E2 I was deeply fixated on the item, which I fondly called a "zaza," and I still remember the last zaza I owned, which I finally lost and which was not replaced by my mother despite terrible wailing. M As the United States entered World War II, DuPont shifted its nylon production from consumer to military production as a replacement for Japanese silk.

O^2 Spring snow comes softly into the tiny mountain town, from the canyons, which have already turned opaque.

[] …as boats have made their way beyond…
A how the ground seeps
what millennia keep

G Near a glacial lake I find dense morning suns on stems, golden asters newly born and already dying.
E3 After humans have become extinct, there will be clusters of chairs.

N Nurdles are tiny plastic resin beads, microplastic precursors to things. T^2 Such is my dinner. I He grabbed the birds from their cages, or scooped them up if they were chicks, and held them up for the crowd to see. S The woman had always re-gretted having little appetite for slaughter—it was a failing a body had to conceal in a place where blood runs like wine—and so she kept her eyes to her feet as she walked through the whetted rubble of the world. S^2 It seemed as if the entirety of evolution was not only pointing to "us" but to the combustion engine—that the entire reason the beings of prehistoric eras lived and died was to lubricate and propel the future perfect present in which we live. I^2 Not to scale, each drawing lacks a sense of ready function: how it plugs into technical systems with their humans, puddles, and toilets.

M^2 Well it could have been an explosion but it was what we called a "violent reaction."

A^2 And when the floods rush in,

L our plastics will live forever, no longer able to decompose, while we become molecules again.

Postscript: Once Were, Now Are, Will Be

Plastic is... remarkably so.

Plastikos, the Greek word meaning able to be molded, became *plastic* in 1909 in the USA: a synthetic product made from oil derivatives.

A hydrocarbon molecule is the smallest base unit of plastic.

A hydrocarbon is a molecule made up of one carbon atom and several hydrogen atoms. We derive large hydrocarbon molecules from refined petroleum, then further "crack" and catalyze them into specialized hydrocarbon forms. A new molecule of carbon and its hydrogen associates comprises a repeatable structural unit, known as a mer. A mer may be linear, branched or networked.

Specific mers create plastics with diverse qualities: PMMA, PVC, PS, PU, PIB, HDPE, and LDPE, to name a few. Their character may be rigid, squishy, porous, bulletproof, brittle or rubbery. A mer can be repeated into long chains, *ad infinitum*. When a mer is repeated, it forms a polymer. Polymers are plastic. Once made, they are exceedingly hard to pull apart; the multitude becomes one. One molecule, infinite forms.

The mer is as Seussian as red buckets piled up to the sky, as silly as a sea of nurdles.

Nurdles are tiny plastic resin beads, microplastic precursors to *things*. Virgin nurdles and their post-consumer doppel-gangers—bits of bottle, bag and net—are carried by sewage and storm drains, swept down rivers, and dumped from sea vessels, arriving in the ocean. Mimicking plankton in size and gestalt, these microplastics are consumed by sea birds, fish, and marine invertebrates. In the Pacific trash vortex (within the North Pacific Gyre), microplastics outweigh zooplankton 6:1. Hormone-disrupting chemical partners cling to these plastic particles, forming an amalgam of Persistent Organic Pollutants, or (more cheerily), POPs. These are synthetic organics, meaning they are man-made. Some of the more familiar POPs include phthalate (the softening agent used in PVC and vinyl), PCB, and BPA (plastic bottle and can liners), which have been linked to endocrine disruption and immune dysfunction. Plastic residues have been found embedded in the guts, tissue, blood and urine of animals from nurdle-eating turtles to bottle-feeding babies.

When a plastic item is used up in the US, it might become landfill or be designated for recycling. In 2011, 32 million tons of plastic was generated in the United States, while only 8% (2.5 million tons) was recovered. Education, access to recycling bins, confusion over sorting, and the persistent belief that plastic biodegrades organically over time, contribute to the low rate of recovery. Of the recycled plastics, some polymers are melted back into nurdles, or ground down into smaller reusable bits, but over 30% of our contaminated or

difficult-to-recycle plastic is shipped to China, the world's largest importer of plastic waste, where it is burned, either in a toxic recycling process or simply as fuel.

In the US we may feel clean about ourselves, outsourcing both the toxic manufacture and recycling of plastics to developing nations (developing cancer), but the problem is pandemic; long after governments ban PCBs and other POPs, the vivid and durable bits of plastic will float outside the boundaries of any empire, and outlive us all.

All organic matter decomposes. We may gradually and anaerobically become future fuel: you and me, our pets, the plankton in the sea, pine trees, paper products, salad scrap and abattoir waste, wooly mammoths, and woolen sweaters. But not plastics. Plastics are intransigent. They disrupt the carbon cycle, as do all fossil fuels. When more carbon dioxide is released into the atmosphere than can be removed, the earth's biosphere undergoes radical changes. This "CO2 liberation" occurs in the extraction of petroleum, the manufacture of plastics, and once again in the recycling process.

Plastics disrupt our biological expectations. Once derived from self-organized biology, now artificially fixed by manufacturing, these petrochemical hydrocarbons will continue to have an intravenous relation to us: from their gravesites within the fissures of geological forms, to their plankton-like drift in our bloodstreams and oceans.

There are over 300 million Hindu deities, permutations on form, each considered to once have been mortal.

Plastic shows up, day after day, as polychrome baubles, life-saving medical equipment, 3D printed weapons, and blameless red buckets. Plastic…these little mers…once were organisms bound to die, now are indefatigable, and will be imperishable, perpetual…immortal.

JAMIE "SKYE" BIANCO is a Clinical Assistant Professor in the Department of Media, Culture and Communication at NYU. She is a queerFeminist and site-based digital media theorist and practitioner whose multimodal work has appeared in *O-zone, Debates in Digital Humanities* (Minnesota, 2012) and *The Affective Turn* (Duke, 2007), and was selected as a local artist for the 2013 Carnegie International exhibition/catalogue.

JOSEPH CAMPANA is a poet, scholar, and arts critic. He is the author of *The Pain of Reformation* and two collections of poetry, *The Book of Faces* and *Natural Selections*. He teaches Renaissance literature and creative writing at Rice University.

RACHEL CANTOR is the author of the novel *A Highly Unlikely Scenario, or a Neetsa Pizza Employee's Guide to Saving the World* (Melville House, 2014) and more than 20 stories published in magazines like the *Paris Review, One Story, Kenyon Review*, and *New England Review*. She lives in Brooklyn, where she is at work on another book.

UNA CHAUDHURI is Professor of English, Drama, and Environmental Studies at NYU. Her recent publications include *Research Theatre, Climate Change, and the Ecocide Project* (co-authored by Shonni Enelow), published by Palgrave, and *Animal Acts: Performing Species Today* (co-edited with Holly Hughes), published by University of Michigan Press.

LUCY CORIN is the author of the short story collections *One Hundred Apocalypses and Other Apocalypses* (McSweeney's Books) and *The Entire Predicament* (Tin House Books) and the novel *Everyday Psychokillers: A History for Girls* (FC2). She spent 2012-13 at the American Academy in Rome as the John Guare Fellow in Literature.

ELIZABETH CRANE is the award-winning author of three collections of short stories, and the novel *We Only Know So Much*. Her work has been featured on NPR's Selected Shorts and adapted for the stage by Chicago's Steppenwolf Theater.

MATT DUBE teaches American literature and creative writing at a small Missouri university. His stories have appeared in *42Opus, Gertrude, KQ*, and elsewhere. He is the fiction editor for the online journal *H_NGM_N*.

HALI FELT is the author of *Soundings: The Story of the Remarkable Woman Who Mapped the Ocean Floor*. She teaches writing at the University of Pittsburgh and is at work on *The Danger Model*, a book about immunology and American conceptions of self.

GABRIEL FRIED is the author of a collection of poems, *Making the New Lamb Take*, and the editor of an anthology, *Heart of the Order: Baseball Poems*. He is the longtime poetry editor at Persea Books.

ELENA GLASBERG writes on visual and performance art culture and teaches in the Expository Writing Program at NYU. She is the author of *Antarctica as Cultural Critique: The Gendered Politics of Scientific Exploration and Climate Change* (Palgrave, 2012).

JAMES GRINWIS lives in Northampton, Massachusetts, and is the author of two books of poetry, *The City From Nome* (National Poetry Review Press) and *Exhibit of Forking Paths* (Coffee House/National Poetry Series). He co-founded Bateau Press in 2007 and his work has appeared widely in journals and magazines.

K. A. HAYS is the author of two books: *Dear Apocalypse* (Carnegie Mellon, 2009) and *Early Creatures, Native Gods* (Carnegie Mellon, 2012). Her poems have appeared in *Best American Poetry 2012, American Poetry Review, The Kenyon Review, Poetry Daily*, and many other venues. She currently teaches creative writing at Bucknell.

NANCY HECHINGER's chapbook *Letters to Leonard Cohen* was published in 2011 by Finishing Line Press. Her poetry has appeared in journals such as *Salamander, Gargoyle, The Mac-Guffin, Sanskrit, Cold Mountain Review, The Wisconsin Review*, and *Mudfish*. She lives in New York City and teaches at the Interactive Telecommunications Program at NYU.

SETH S. HOROWITZ earned a Masters in psychology and a Ph.D. in neuroscience from Brown University. A former professor in the Department of Neuroscience at Brown, he has worked and published in comparative and human hearing, balance, sensory integration, sleep, and space science. He is the author of *The Universal Sense: How Hearing Shapes the Mind* (Bloomsbury, 2012).

CHRISTINE HUME is the author of three books, most recently *Shot* (Counterpath, 2010), and three chapbooks, *Lullaby: Speculations on the First Active Sense* (Ugly Duckling Presse, 2008), *Ventifacts* (Omnidawn, 2012), and *Hum* (Dikembe, 2014). She teaches in the interdisciplinary creative writing program at Eastern Michigan University.

DAVID M. JOHNS is a co-founder and past president of the Wildlands Network and the Yellowstone to Yukon Conservation Initiative. He has written and spoken widely on the integration of science and advocacy and science and policy. Author of *A New Conservation Politics* (2009), he has published in *Conservation Biology* and *Environmental Ethics*, among others. David teaches politics and law at Portland State University.

OLIVER KELLHAMMER is a Canadian land artist, permaculture teacher, activist and writer. His botanical interventions and public art projects demonstrate nature's surprising ability to recover from damage. Recent research has focused on ruin ecologies and strategies for adapting the landscape to climate change. Since this interview took place, his father has been re-diagnosed with non-Hodgkins lymphoma and is awaiting the results of more tests.

MELISSA KWASNY is the author of five books of poetry, including *Pictograph, The Nine Senses*, and *Reading Novalis in Montana*, all from Milkweed Editions. A collection of essays, *Earth Recitals: Essays on Image and Vision*, was published by Lynx House Press in 2013.

Max Liboiron is a scholar, activist, and artist. Her research, including her dissertation, "Redefining Pollution: Plastics in the Wild," focuses on how invisible harmful emerging phenomena such as disasters and plastic pollution are made manifest in science and activism, and how these methods of representation relate to action. Liboiron also manages the Discard Studies Blog.

Maureen N. McLane is the author of three books of poetry, including *This Blue* (FSG, 2014), as well as a hybrid work of memoir and criticism, *My Poets* (FSG, 2012), which was a *New York Times Notable Book* and a Finalist for the National Book Critics Circle Award in Autobiography. A carbon-based creature, she teaches at NYU and has written poems on weird life and books on British romanticism.

Michael Mejia is the author of the novel *Forgetfulness* (FC2), and his fiction and nonfiction have appeared in many journals and anthologies, including *AGNI, DIAGRAM, Denver Quarterly, Seneca Review*, and *My Mother She Killed Me, My Father He Ate Me*. He has received a Literature Fellowship in Prose from the NEA and a grant from the Ludwig Vogelstein Foundation. A co-founding editor of Ninebark Press, he teaches at the University of Utah.

Timothy Morton is Rita Shea Guffey Chair in English at Rice University. He is the author of *Hyperobjects: Philosophy and Ecology after the End of the World* (Minnesota, 2013), *Realist Magic: Objects, Ontology, Causality* (Open Humanities Press, 2013), *The Ecological Thought* (Harvard, 2010), *Ecology without Nature* (Harvard, 2007), seven other books, and ninety essays on philosophy, ecology, literature, food, and music.

Lydia Millet is a novelist whose most recent book, *Mermaids in Paradise*, is forthcoming from W.W. Norton in fall 2014. She lives in the desert outside Tucson, Arizona with her children.

Duncan Murrell is a writer and documentarian from North Carolina. He is currently the writer in residence at The Center for Documentary Studies at Duke University, and a contributing editor at *Harper's Magazine* and *The Oxford American*.

Ruth Ozeki is a writer, filmmaker, and Zen Buddhist priest. She is the best-selling author of the novels *A Tale for the Time Being, My Year of Meats*, and *All Over Creation*. Translated and published in more than thirty countries, her books have garnered international critical acclaim for their ability to integrate issues of science, technology, environmental politics, and global pop culture into unique hybrid narrative forms.

Cecily Parks is the author of the poetry collection *Field Folly Snow* (Georgia, 2008). Her second collection, *O'Nights*, will be published by Alice James Books in 2015.

ABIGAIL SIMON uses photography, video, and humble cultural objects to reframe conversations about history, technology, and consumer culture. Her portraits, videos and installations have been widely exhibited at museums and galleries around the world, including The International Center of Photography, The Bronx Museum, The AIR Gallery, EFA Gallery, and Governor's Island. She is a founding member of The Brooklyn Association for the Discussion of Camera-based Art and Theory (BADCAT).

SUSAN SQUIER is Brill Professor of Women's Studies and English at Penn State, where she also raises chickens. Her most recent books are *Liminal Lives: Imagining the Human at the Frontiers of Biomedicine* and *Poultry Science, Chicken Culture: A Partial Alphabet.*

VALERIE VOGRIN has published a novel, *Shebang.* Her stories have appeared in journals such as *Ploughshares, AGNI,* and *The Los Angeles Review.* In 2010 she was awarded a Pushcart Prize.

NICOLE WALKER's *Quench Your Thirst with Salt* won the Zone 3 Award for Creative Nonfiction and was released in June 2013. She is the author of a collection of poems, *This Noisy Egg* (Barrow Street, 2010). She's nonfiction editor at *Diagram* and associate professor at Northern Arizona University in Flagstaff.

DOUGLAS WATSON is the author of a book of stories, *The Era of Not Quite.* His novel, *A Moody Fellow Finds Love and Then Dies,* will be published on April Fool's Day 2014 by Outpost19.

KELLIE WELLS is the author of *Compression Scars,* winner of the Flannery O'Connor Prize, and two novels, *Skin* and *Fat Girl, Terrestrial.* She teaches in the graduate writing programs at the University of Alabama and Pacific University.

DEREK WOODS is a Ph.D. student in English and an amateur lichenologist. He writes essays on theory and environmental literature, and contributes to the Organism for Poetic Research (organismforpoeticresearch.org). Derek lives in Houston and Vancouver.

Crossing multiple disciplines with her practice, MARINA ZURKOW builds animations, media, and participatory environments focused on humans and their relationship to animals, plants, and the weather. She is the recipient of a 2011 John Simon Guggenheim Memorial Fellowship. She has also been granted awards from the New York Foundation for the Arts, New York State Council for the Arts, the Rockefeller Foundation, and Creative Capital. She is on the faculty at NYU's Interactive Technology Program (ITP) and lives in Brooklyn.

Drawing Assistance: Ellen Anne Burtner

Additional Research: Miriam Simun

Artwork courtesy of the artist and bitforms gallery

Thanks to the John F. Simon Guggenheim Memorial
Foundation Fellowship, bitforms gallery, and Eileen Joy.

The Petroleum Manga is part of *Necrocracy*, an ongoing
body of work first developed as part of a solo exhibition
commissioned by DiverseWorks in Houston, Texas and
presented in March 2012.

www.o-matic.com/play/necrocracy

Lucy Corin:
 "Half" and "Freeze Box" first appeared in *West Branch*.
 "Meth" and "After" first appeared in *Massachusetts Review*.
 "Body" first appeared in *8 O'clock*.
 "Sail, Hull, Jibs" first appeared in *Diagram*.

Melissa Kwasny:
 "Past Life with Wooly Mammoth" first appeared in
 Terrain.

David M. Johns:
 Condom slogans used with permission of The Center for
 Biological Diversity.

Michael Mejia:
 "A Camera's Not Expression..." first appeared in *Diagram*.